SCARBOROUGH
IN 50
BUILDINGS

MIKE SMITH

AMBERLEY

To Jo-Ann, for your unfailing help, advice and support throughout the preparation of this book.

And to Charlotte, for your invaluable contribution.

First published 2021

Amberley Publishing, The Hill, Stroud
Gloucestershire GL5 4EP

www.amberley-books.com

British Library Cataloguing in Publication Data.
A catalogue record for this book is available from the British Library.

ISBN 978 1 3981 0173 9 (print)
ISBN 978 1 3981 0174 6 (ebook)

Typesetting by SJmagic DESIGN SERVICES, India.
Printed in Great Britain.

Contents

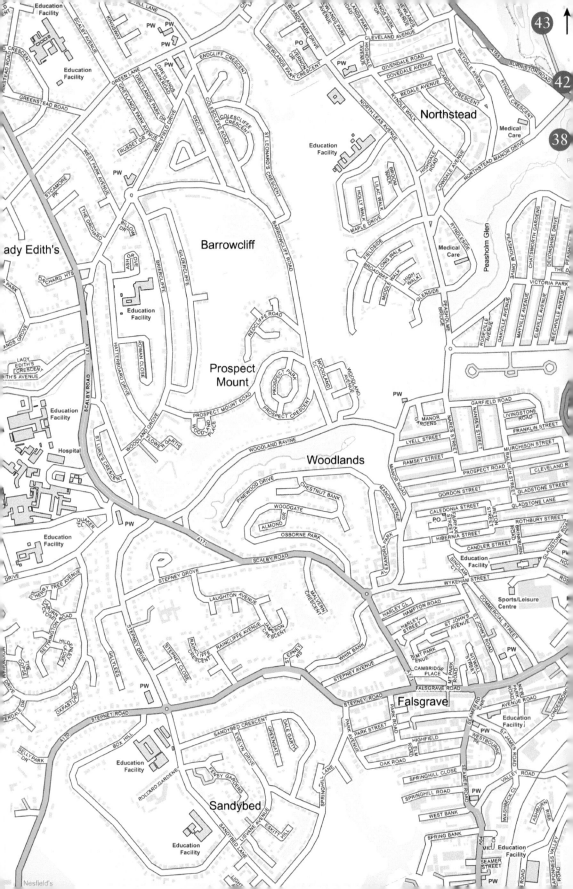

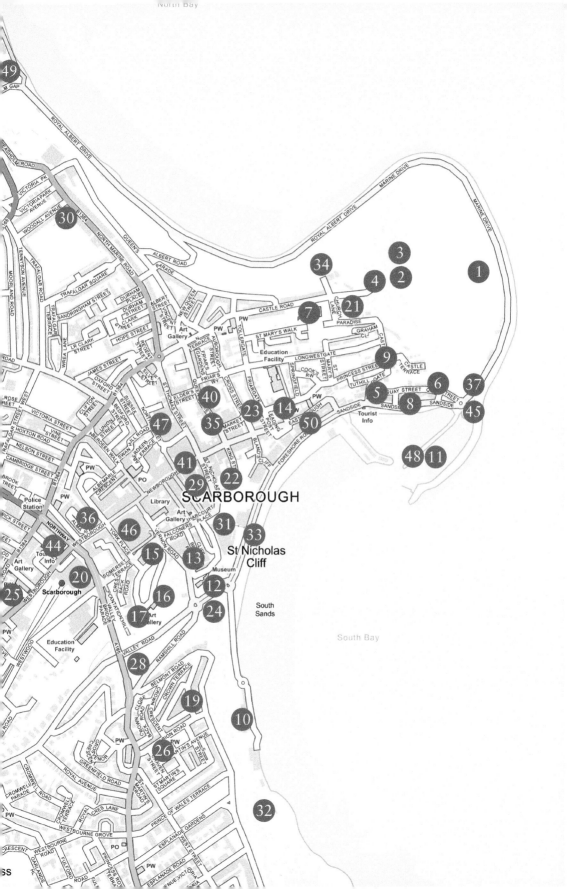

Key

Introduction

Scarborough's two magnificent bays are separated by a headland bearing the remains of a Roman signal station and the substantial ruins of a twelfth-century keep. During the Civil War, an exchange of fire took place between Royalists defending the keep and Parliamentarians based at St Mary's Church – both buildings still bear the scars. The harbour beneath the headland provided anchorage for a fleet assembled by Richard III, who stayed at a house on Sandside, a street later associated with shipbuilding and with providing lodgings for the 'herring girls' who processed the local catch.

Several houses in the steep streets above Sandside date from the days when John Wesley came to 'spread the word'. By Wesley's time Scarborough had developed into a spa, thanks to the discovery in 1626 of health-giving spring waters, and had become Britain's first seaside resort. Today, the spa buildings include a three-tiered concert hall and a Sun Court with panoramic views. A walkway to the spa, constructed in 1827, is the most elegant 'flyover' to be found anywhere.

The classical Rotunda beneath the walkway is the world's first purpose-built museum, designed in 1829 to illustrate William 'Strata' Smith's identification of strata by their fossils. Its architect, Richard Hey Sharp, also designed the Seamen's Hospital and the stylish Crescent, commissioned by John Uppleby, who monitored its development from his residence, which is now Scarborough Art Gallery. The eccentric Sitwell family lived next door, at Woodend.

Scarborough acquired its first purpose-built hotel in 1844, shortly before the railway arrived, heralding the age of mass tourism. Like many people, Anne Brontë visited Scarborough to improve her health, but she could only find peace before passing away in the resort in 1849. The Grand Hotel, built in 1867 as Europe's biggest hotel, has been described as 'towering over South Bay like a massive brick ocean liner'. Other impressive Victorian buildings include the neo-Jacobean Town Hall; a Tuscan-style market hall; St Martin-on-the-Hill Church, with its glorious pre-Raphaelite windows; Baldwin Stewart's monumental Westborough Methodist Church and his forbidding Scarborough Prison. The country's first funicular railway, built in 1873, still operates, as does one of four others constructed subsequently. A third surviving lift has been anchored at its summit and converted into a café with breathtaking vistas.

Victorian Scarborough was captured perfectly by the artist John Atkinson Grimshaw, who lived at Castle by the Sea, a hilltop house overlooking both bays. North Bay was opened up in 1897 by the construction of a Marine Drive, paving

the way for the twentieth-century extension of the resort into Peasholm Gap, where an East Asian-themed park, an open-air theatre and a miniature railway were constructed.

Scarborough's finest twentieth-century building is an art deco cinema, now converted into the Stephen Joseph Theatre, known for premiering Alan Ayckbourn's plays and named after the director who pioneered theatre-in-the-round. Twenty-first-century architecture is best represented by the Sands holiday apartments and by a new lift bridge leading to Scarborough's lighthouse – one of many iconic structures described in this book.

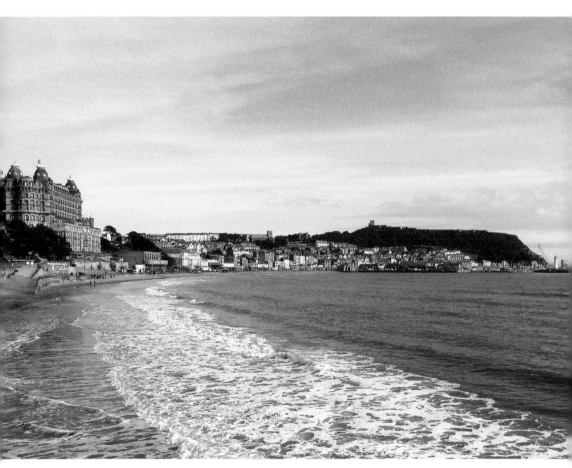

Scarborough's South Bay seen from the Spa.

The 50 Buildings

1. The Roman Signal Station

Scarborough's two magnificent bays are separated by a 150-metre-high headland that shakes a defiant fist at the incoming wild waters of the North Sea. As the Romans realised, the massive promontory is perfectly placed to give early warnings of approaching hostile vessels. An excavation carried out in the 1920s on the extreme eastern edge of the headland uncovered the remains of a fourth-century signal station, one of a chain of early warning installations constructed by the Romans along the North Sea coast between Saltburn and Flamborough Head.

The excavated remains of the Roman signal station.

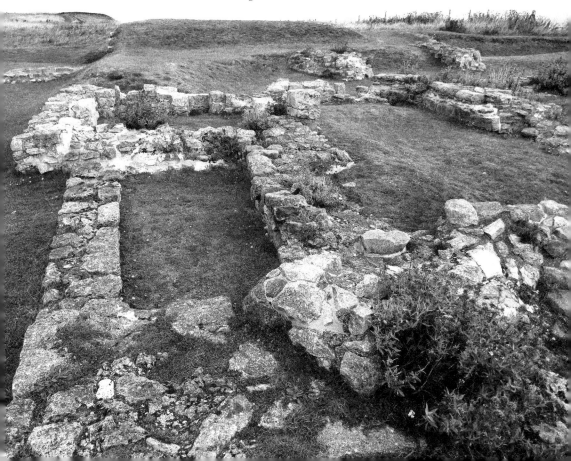

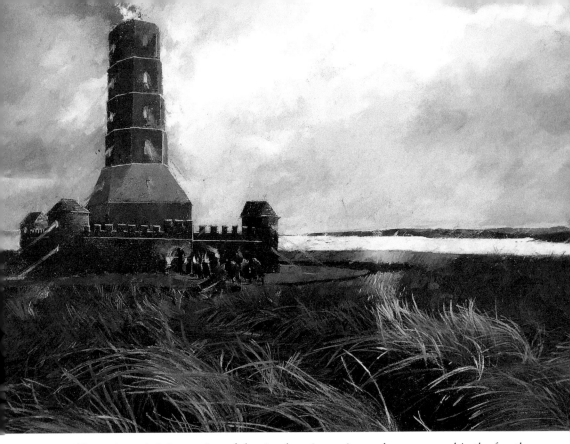

Above: An artist's impression of the signal station as it may have appeared in the fourth century.

Below: The remains of St Mary's Chapel.

Even though a small section of the outer enclosure walls on the seaward side had slipped over the edge of the cliff, the excavators were able to reveal that the station consisted of three square-shaped enclosures, arranged concentrically like a set of Russian dolls. Of course, the task of mentally reconstructing the form and height of the structures contained within these enclosures has entailed a lot of guess work. According to English Heritage, foundations uncovered at the core of the site suggest that there could have been a 6-metre-high central tower surmounted by a beacon or lookout, and the timber posts that were unearthed may well have been supports for corner towers. These speculations form the basis of the dramatic visualised reconstruction of the Roman signal station depicted on the interpretation board at the entrance to the site.

Although personnel employed at the station had to endure the worst of the North Sea gales, they were fortunate in having access to fresh water emanating from a well, later known as the Well of Our Lady. In around AD 1000, a chapel dedicated to Our Lady was constructed over the foundations of the signal station by employing some of the building stones used by the Romans. The chapel was extended in subsequent years, but very little of it now remains above ground level. Nevertheless, the presence of Roman and medieval ruins in the same location has made interpretation of the excavation site difficult and fascinating in equal measure, not just for archaeologists but also for present-day tourists visiting the site.

2. King Henry II's Great Tower

Although the profiles of the above-ground features of the Roman signal station are a matter of speculation, the shape of the castle built by Henry II on the western edge of Scarborough's headland is clear for all to see. The three-storey, 27-metre-high keep, constructed between 1159 and 1169, remains a commanding presence, despite considerable damage inflicted in a siege that took place in 1645.

Much of the outer skin of the western side of the structure was ruined in the siege, leaving the interior rooms exposed to the elements. Viewing the ruined keep from the western side is like looking at a cut-away diagram drawn to illustrate the internal layout of the tower, which comprises a first-floor hall and two second-floor chambers. The eastern side of the structure was relatively undamaged.

The tower is entered, as it may have been in medieval times, through a raised doorway that is approached from a flight of steps on its southern face. It is thought that all the floors in the keep were connected by a spiral stairway running up what is now the lost western side of the structure. The lowest steps of this stairway are still visible.

The castle became a northern stronghold for the Crown and Scarborough was named a Royal Borough. Over the following six centuries, the castle saw a great deal of action. In 1312, it was attacked by a group of barons, who forced the governor, Piers Gaveston, to surrender, promising he would be kept in safe hands.

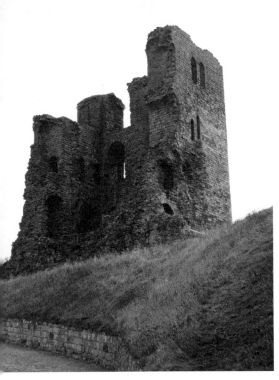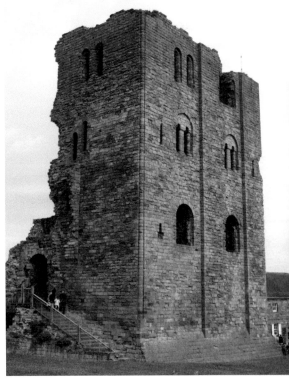

Above left: The ruined western side of Henry II's keep.

Above right: The more intact eastern side of Henry II's keep.

However, the barons failed to prevent Gaveston's capture by the Earl of Warwick, who sent him to a trial that resulted in his execution. In 1645, the castle was subjected to a siege by Parliamentarians, who bombarded the stronghold with cannonballs without managing to breach the outer defences. Nevertheless, the Royalists holding the castle were eventually forced to surrender.

On the morning of 16 December 1914, two German battlecruisers opened fire on the castle and the town. Building on the public outrage about the resulting loss of life, recruitment officers used 'Remember Scarborough' as a rallying cry.

3. The Castle Exhibition and the Master Gunner's House

After the Civil War, Scarborough Castle served as a prison. Following the Jacobite Rebellion of 1745, a military barracks was erected on the headland, and the use of the castle as a military base continued right up to 1920, when the site was acquired by the state and the garrison blocks were demolished. However, a dwelling constructed in 1748 for the master gunner was allowed to remain.

The Master Gunner's House is a neat two-storey structure with two Dutch-style stepped gables. It was altered during the Napoleonic Wars (1803–1815) to create accommodation for a storekeeper, while retaining the lodgings for the

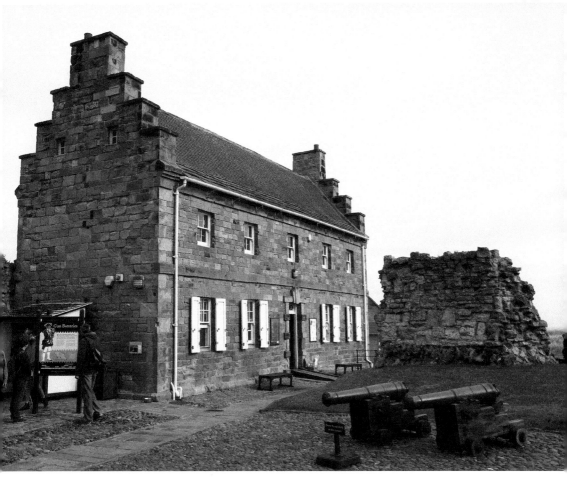

The Master Gunner's House.

master gunner. Plans dating from the early nineteenth century show a cellar, a parlour and a kitchen on the ground floor, two bedchambers on the first floor and three rooms in the attic.

The internal layout is now much simpler: the ground floor houses a café, supplemented by outside seating, and the upper rooms contain illustrated interpretation panels covering the history of the headland. Visitors to the exhibition are even invited to try on some replica costumes from both the Roman era and medieval times to help bring that history to life.

4. The Castle Barbican and Gate

Visitors enter Scarborough Castle through a formidable barbican gate flanked by two half-moon towers. If you look closely at the left-hand tower you will spot an oddly shaped stone, thought to be the remains of a fifteenth-century shield decorated with the royal arms. Although the gate has been altered considerably, English Heritage claim that its overall appearance closely resembles the form of the original gate constructed in around 1300.

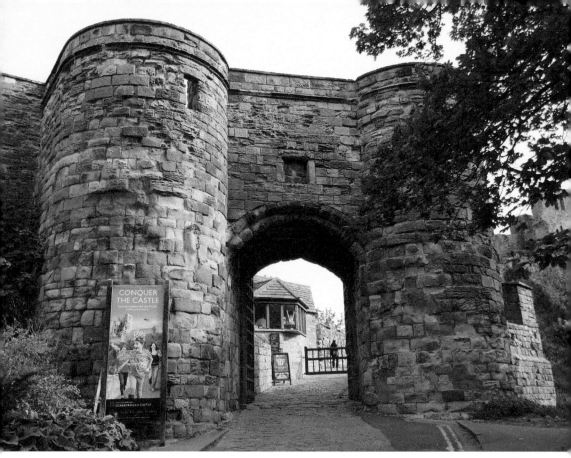

The barbican gate.

Having passed through the gateway, you walk through the barbican to the ticket office and then follow a path that passes between fortified walls until you step onto a bridge that crosses over a deep ditch, before you make your final approach to the great tower. It is an impressive entrance to a fortress that retains its unassailable appearance despite the disappearance of most of the curtain walls that once encircled the entire headland on which it stands.

In contrast to the physical barriers that deterred potential invaders of old, today's visitors are made welcome by friendly and informative staff. And young sightseers are entertained, not only by a variety of games laid out for their use, but also by an invitation to take part in a mock cannon firing.

5. King Richard III's House

According to a tentative claim inscribed on a blue plaque attached to a tall gabled building in Sandside, 'King Richard III, 1483–1485 is reputed to have stayed here.'

Is there any evidence to show that the monarch might have taken up residence here at some point? According to Jeremy Clark, the author of a comprehensive description of the building's history, King Richard was in Scarborough on

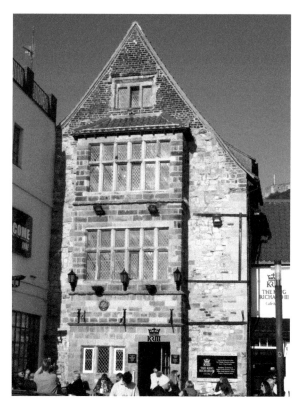

Right: King Richard III's house.

Below: The king is 'reputed to have stayed here'.

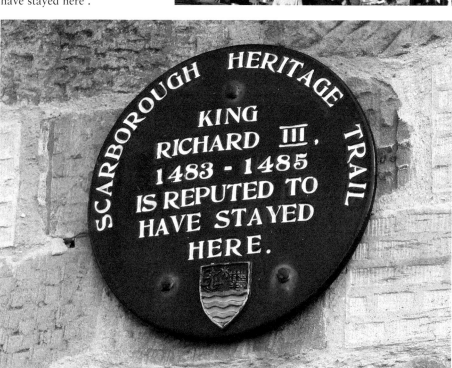

22 May 1484 and again from 30 June to 11 July, with the purpose of gathering a fleet to resist an expected invasion led by Henry Tudor. Although there is documentary evidence to show that he stayed at Scarborough Castle in that year, there is no proof that he also resided for a time during his visit in a house in Sandside. However, as Mr Clark points out, Sandside would have been a convenient location for him to keep a careful eye on the ships he had assembled in the harbour.

But what of the building itself? Could this tall stone structure with its prominent three-storey projecting bay really date from the fifteenth century? According to Mr Clark, that wonderful bay, with its mullioned and transom windows, is actually a faithful replica of a seventeenth-century feature that had been removed in the nineteenth century. The replica bay was installed in 1915 by Edgar Burrows and was based on a drawing dating from 1835. The drawing, reproduced in the Scarborough Philosophical Society Reports of 1846–65, purports to show the seventeenth-century appearance of the building, complete with the bay.

The decorated plaster ceiling in an upper room known as the King's Bedchamber also turns out to be seventeenth century. Its details include depictions of parrots, sea serpents and bulls. The carved centrepiece of the ceiling is thought to depict the 'Rose of York', Richard's family emblem, and some of the structure of the ground-floor rooms could date from the fifteenth century and be part of a house owned by Thomas Sage.

Whatever the true provenance of the building, which now houses a popular restaurant, King Richard III's House is a striking and much-loved presence on Scarborough's seafront.

6. The Ancient Pubs of Quay Street

A private house in Quay Street is the former Three Mariners Inn, one of Scarborough's oldest and best-known pubs. Parts of its structure date back to the fifteenth century. Before the building was put on the market in 2015, it had been occupied for seventeen years by the antique dealer Ken Wood and his wife Angie. Ken told Sharon Dale of the *Yorkshire Post*: 'To me the building was one big antique. I just had to buy it.'

Although Ken's original plan had been to convert the building into a themed holiday let or a museum, he and Angie ended up living in the former inn, which Ken restored with the help of his brother-in-law. Before their restoration work could begin, an archaeological survey had to be carried out. This uncovered pottery and fourteenth-century roof tiles made from limestone. Other discoveries included a French prayer book dating from the 1700s and another book giving details of sales of tobacco and pipes. Ken believes that the many nooks and crannies he found in the building during the renovation may have been used to conceal smuggled goods and to hide Catholics who were subject to persecution. His claims are supported by evidence uncovered by local historians that the

Above: The Three Mariners Inn.

Right: The former Dog & Duck Inn.

Three Mariners was used by smugglers and notorious renegades, who came to the inn to sup ale, hide contraband and seek sanctuary. The Three Mariners is also said to have been a watering hole favoured by artists such as Atkinson Grimshaw.

The frontage of the building was refashioned in brick during the seventeenth century, but the original fifteenth-century timber framing was left exposed on the gable end, and it remains a feature to this day. Similar timber framing has survived on a building located a few yards away. This is the former Dog and Duck, another of the seven pubs that existed in the Quay Street area – a proliferation explained by the street's proximity to Scarborough's once busy shipbuilding yards. In fact, the Three Mariners Inn was once known as the Blockmakers' Arms – a reference to the manufacturers of the wooden pulleys used in the town's famous sailing ships.

7. St Mary's Church

St Mary's Church, which stands high above Scarborough's Old Town and is the area's parish church, is a fascinating building fashioned in beautiful brown stone.

The porch and south window of St Mary's Church.

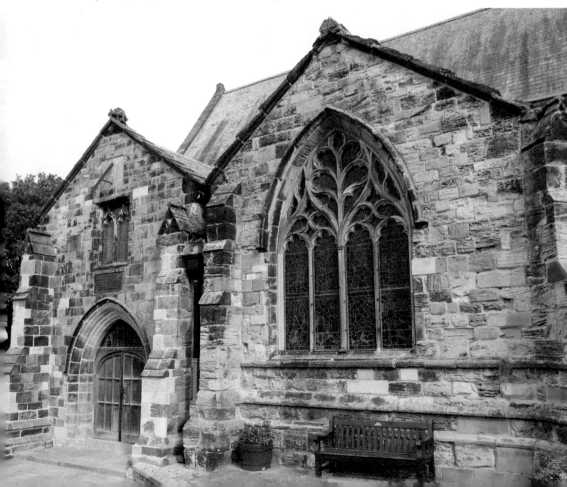

It was built in 1150 with a single aisle, but was enlarged in 1180 when the nave was widened, the west front was added and the construction of three towers began. Between 1200 and 1225, north and south aisles were added and, in the fourteenth century, a choir was constructed in Perpendicular style, increasing the overall length of the church by 63 metres.

St Mary's Church seen from the harbour (clock installed in 1950).

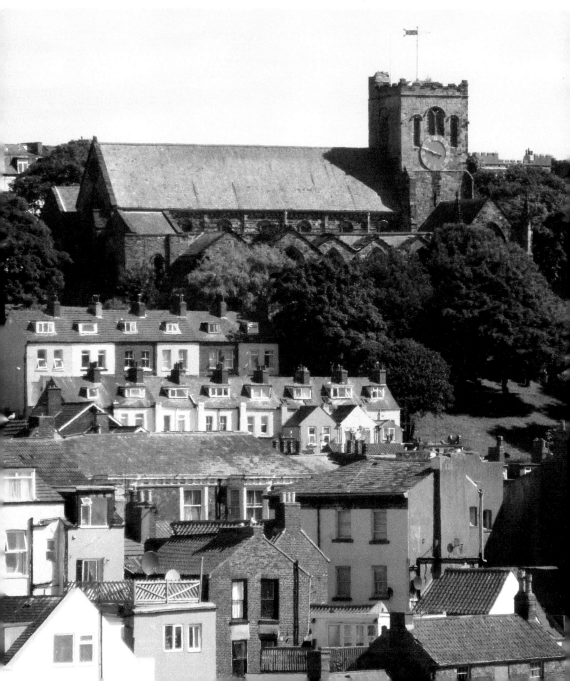

In 1645, this great building suffered a terrible disaster. Parliamentarians gained access to the church and installed two canons to enable them to attack the nearby castle. During a ferocious exchange of fire with the Royalists who were defending the castle, 'great mischief' was done to St Mary's, involving the destruction of the glorious medieval choir and the north transept. To make matters worse, the central tower was so badly weakened that it finally collapsed in 1659. Ten years later, sufficient funds had been raised to rebuild the nave, the St Nicholas Aisle and the central tower, but the amount of money collected was insufficient to finance the reconstruction of the north transept and the choir.

After this partial restoration of the church's medieval glory, St Mary's suffered from an 'attack' of a very different nature. In the words of a leaflet produced by the Parish Office: 'Over the next 150 years, there followed a period of architectural vandalism.' This is clearly a reference to the construction of box-pews, flying staircases and galleries, all installed with the intention of increasing seating capacity. Fortunately, most of this clutter was removed in a restoration carried out between 1848 and 1850, during which time the church was closed.

Since this time, further improvements have taken place, not least the addition in 1950 of an enormous, blue-faced clock on the central tower and the construction in 1993 of a new Lady Chapel. However, the ruined eastern areas of the church remain. They are a vivid reminder of the terrible bombardment that took place in 1645.

8. The Former Shipbuilding and Herring-fishing Area

Plaques and installations on a beautifully renovated Georgian-style house on the harbourside commemorate two of Scarborough's most important former industries, both of which were based on the South Sands, located in front of the building.

A heritage trail plaque on the house identifies its location as being 'the scene of busy shipbuilding activities in the 17–19th centuries'. According to the introduction to an excellent permanent exhibition in the Maritime Heritage Museum, over 400 vessels were built in Scarborough's shipyards during this period, with the largest of the vessels weighing over 400 tons. The most successful shipbuilders were members of the Tindall family, who constructed sailing vessels used to transport troops to fight in the American War of Independence. They also made other ships, such as *The Scarborough*, to carry the first convicts sentenced to be transported to Australia.

In the late eighteenth century, 30 per cent of the town's employment was based on shipbuilding and related trades. According to literature accompanying the shipbuilding exhibition, 'ship launches were gala events accompanied by cake and liquor'. Scarborough's thriving shipbuilding industry died out very quickly when iron and steam replaced wood and sail, although the last boatyard survived until 2009.

A superb installation by Bill Corduroy on the wall of the red-brick house in Sandside commemorates a different type of activity, which flourished up to the

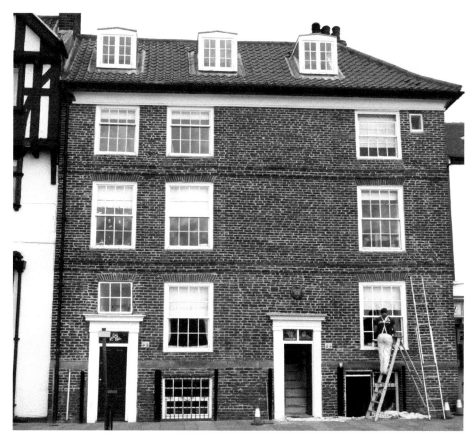

Above: A building that provided accommodation for shipbuilders.

Right: An installation by Bill Corduroy illustrating the 'herring girls' at work.

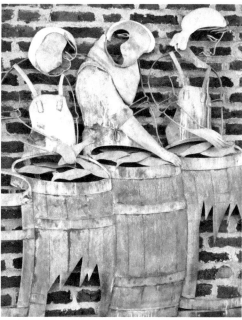

1960s. Based closely on early photographs, the installation illustrates the work of the famous 'herring girls'. According to the text on an accompanying plaque, written by Fred Normandale:

> Vast shoals of herring would migrate down the North Sea from North East Scotland – the place where herring fishing had first begun in the ninth century. In the first week of August to early September, the herring would be spawning off the Yorkshire coast, when vessels came from near and far to harvest the 'silver darlings'. The catches were gutted, salted and barrelled by 'herring girls' from the north east of Scotland, some of whom lodged in this building during the season.

9. John Wesley and the Eighteenth-century Buildings of Castlegate

Scarborough's Old Town comprises a maze of streets and alleyways that cling to the hillside linking the harbourside with the hilltop St Mary's Church. The most visually satisfying of these streets is Castlegate, a steep road flanked by eighteenth-century town houses. Typical of their time, the dwellings are neat in their proportions and tasteful and restrained in their appearance.

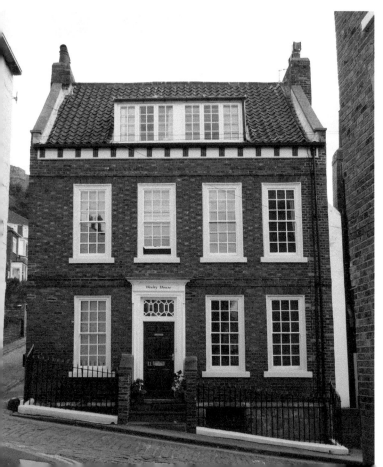

Wesley House.

Looking towards the harbour from Castlegate.

The most striking dwelling on the street is Wesley House, best appreciated from Princess Street, which approaches Castlegate from the west. The Grade II listed building, fashioned in Dutch 'chequer brick', has a four-bay frontage with a neat array of seven sash windows, punctuated by a six-panelled doorway surmounted by a rectangular decorated fanlight. The parapet has a wooden triglyph frieze and a

moulded cornice gutter. Its pantile roof has a wide dormer that was added in more recent times. All in all, this is one of the most attractive houses in Scarborough.

John Wesley first visited Scarborough in 1759, riding into town from Robin Hood's Bay over what he described, in typically exaggerated fashion, as 'huge mountains'. Thirty-two years later, when he died at the age of eighty-eight, he had made over a dozen visits to the Yorkshire town. Recounting his experience on one of these occasions, he wrote: 'I had designed to preach abroad in the evening, but the thunder, lightning and rain persisted. However, I stood on a balcony, and several hundred people stood below, and, notwithstanding the heavy rain, would not stir until I concluded.' Writing in his journal about a visit he made to the town on Thursday 15 June 1786, he reported, 'I found the work of God at Scarborough more lively than it had been for many years.'

Wesley's stirring rhetoric obviously made a number of converts among the fishing community. A 30-ton yawl was named *John Wesley*. The boat was lost with all its crew on 28 October 1869. Another yawl was called *Temperance Pledge*. This vessel was badly damaged in a storm on 30 January 1877, but survived and remained in service until 1899.

10. The Spa

According to an account written in 1667 by Dr Wittie, a lady called Thomasin Farrer was walking on the beach in the 1620s when she noticed that some pebbles had been stained a russet colour by a spring emerging at the foot of 'an exceedingly

The Scarborough Spa.

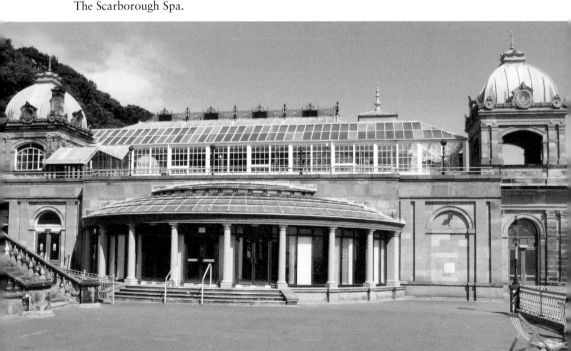

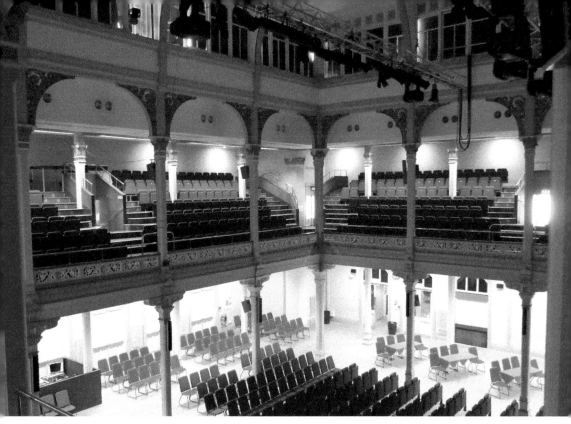

Above: The Grand Hall at the Spa.

Below: The Sun Court.

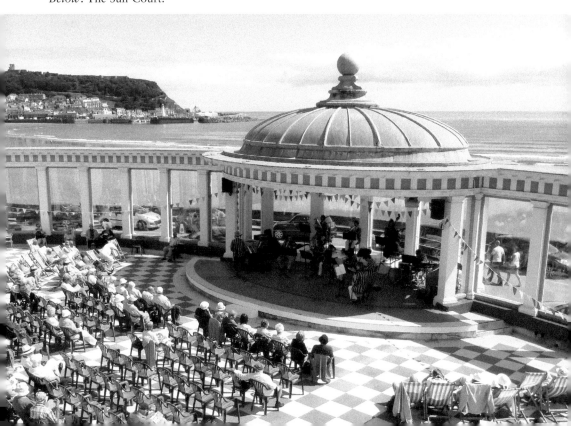

high cliffe'. Although she found the spring waters to be rather bitter, Thomasin suggested that they might possess medicinal properties. Seduced by her claim, people began visiting Scarborough to take advantage of the health-giving waters.

A 'Spa House' was built in the early 1700s and, by the mid-century, Scarborough had become established as a spa town and a seaside resort, becoming one of the first places in the country to install bathing machines. In 1737, a massive cliff fall destroyed both the Spa House and the well. Knowing the prosperity of the town depended on its reputation as a spa, the civic leaders lost no time in resurrecting the wells and building a replacement Spa House, which included a saloon overlooking the sea.

A new Gothic Saloon and Concert Hall, designed by Henry Wyatt, was constructed in 1839, but the number of visitors became so great that Wyatt's building could not contain them, so Joseph Paxton, noted for his work at Chatsworth House in Derbyshire, was called in to design larger facilities. He came up with a central assembly hall, galleries, a bandstand and a colonnade with a line of shops.

On 8 September 1876, a second disaster struck when the Spa Saloon was destroyed by fire. Once again, civic leaders lost no time in putting right the damage by commissioning a new Grand Hall, which opened in 1879. In recent years, the hall's three-tiered, colonnaded auditorium has undergone two phases of restoration, which have emphasised the grand proportions that make this one of the finest concert halls in the country.

In addition to the Grand Hall, the current spa complex comprises the Spa Theatre, the Spa Ocean Room and the wonderful open-air Sun Court, where audiences can listen to concerts while enjoying fabulous sweeping views of South Bay and the great headland that overlooks it.

11. The Lighthouse

With its gleaming white tower and distinctive lantern, the lighthouse at Scarborough is one of the town's most prominent landmarks. Although the building looks as if it has stood for centuries, the lighthouse in its present form dates from 1931, when the most recent of several rebuilds took place.

According to freelance writer Faith Young, the first lighthouse to be built in Scarborough's harbour was constructed in 1804. In its original form, the lighthouse was a flat-roofed brick structure surmounted by a coal brazier that burnt during the night to give approaching ships a clear marker. It would seem the daytime warning took the simple form of a flag.

After a few years, the coal-fired brazier was replaced by an array of tallow candles. By the 1840s a gas supply had arrived, allowing a gas-filled lantern to be constructed. In addition, accommodation was built alongside the lighthouse for the harbour master and his family. In 1850, the lighthouse acquired a second

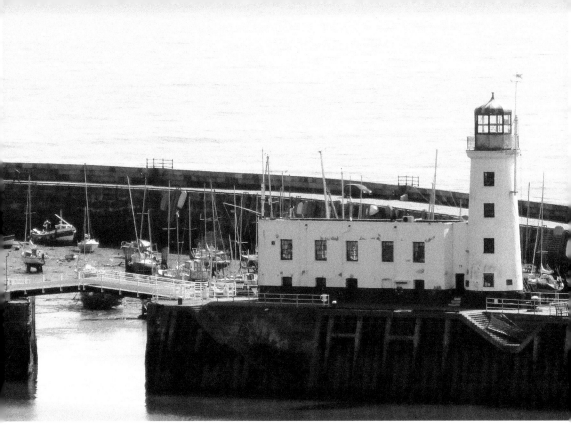

Above: The lighthouse and the harbour.

Right: The lighthouse, now the headquarters of the Scarborough Yacht Club.

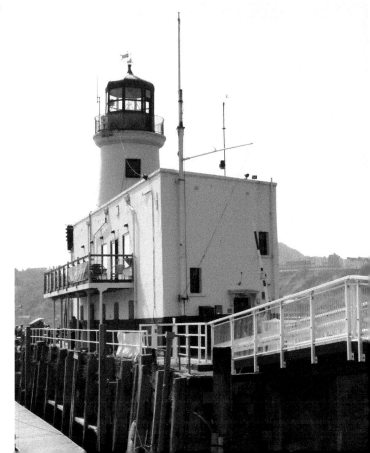

storey and a domed top, extending its height by 5 metres. The structure retained this appearance until the fateful day of 16 December 1914, when 500 shells were fired at the town from two German battlecruisers. The lighthouse suffered a direct hit that caused a gaping hole to appear in the structure. In fact, the damage was so great that the tower had to be dismantled to first-floor level.

Surprisingly, the lighthouse was allowed to remain in this sorry state until 1931, when enough money was finally raised by public subscription to allow reconstruction to take place. The restoration included the addition of a foghorn, which issues a thudding boom whenever sea fret closes in from the North Sea, a sound familiar to regular visitors to the resort. The foghorn was also used as an air-raid warning device in the Second World War.

Nowadays, the lighthouse buildings provide a base for the Scarborough Yacht Club and the white tower remains a much-loved landmark.

12. The Cliff Bridge Walkway (also known as the Spa Bridge)

Access to the spa from the St Nicholas Cliff area of the town was made far easier by the opening, on 19 July 1827, of a high-level path known as the Cliff Bridge

The Cliff Bridge, linking the town with the Spa.

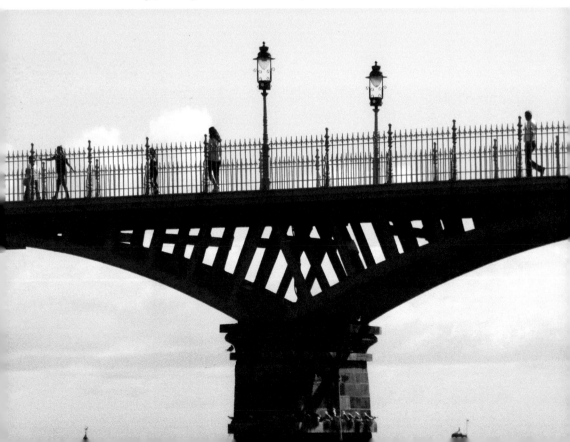

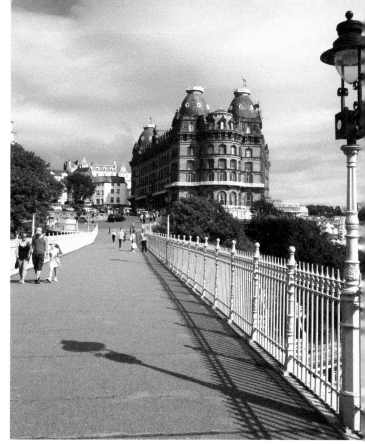

Right: The entrance to the Cliff Bridge from the Grand Hotel.

Below: The bridge leading to the Spa.

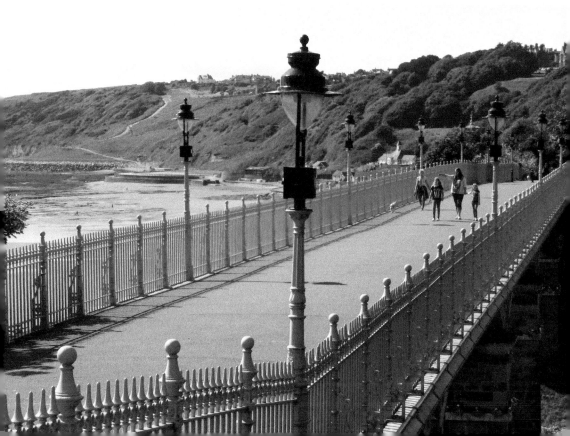

Walkway. It had been commissioned by the Cliff Bridge Company as a way of increasing visitor numbers and maximising the potential of the spa complex, which had been leased to the firm by the Corporation. A tollbooth was erected at the St Nicholas Cliff end, with season tickets being made available for periods of two or four weeks. A grand formal opening of the structure, which became known as the Penny Bridge, was attended by local dignitaries and attracted huge crowds, who were entertained by the alarming sight of a mail coach and horses galloping across the high-level walkway at great speed.

The Cliff Bridge, now more commonly known as the Spa Bridge, is a spectacular structure. Its walkway, 136 metres long and 4 metres wide, is set on three cast-iron arches supported by three tapering 21-metre-high pillars that rise elegantly from the floor of the deep ravine that had made access to the spa so difficult before the construction of the bridge. In marked contrast to many modern flyovers, which are usually intrusive and unsightly, this nineteenth-century engineering masterpiece makes a positive and elegant contribution to the townscape. Since the opening in 1867 of the Grand Hotel on the summit of St Nicholas Cliff, the walkway has become the perfect physical and visual link between the monumental hotel and the spa complex.

Being exposed to the weather, the bridge requires regular maintenance. Between November 2009 and April 2010, it underwent a £700,000 restoration involving repainting and the installation of new timber beams and new paving. Ever since the removal of the tollbooths when the Corporation bought back the bridge in 1957, the walkway has become one of the best free attractions in Scarborough. It is a great place for promenading and for taking in fabulous views, not only those obtained by looking over the town and South Bay, but also by more distant prospects stretching southwards towards Filey Brigg.

13. The Rotunda

Immediately after leaving St Nicholas Cliff and stepping onto the Spa Bridge, cast your eyes to the right and look down on a building that looks as if it has been transported to the Yorkshire Coast from Classical Rome. This surprising presence is the Rotunda, built in 1829 as one of the world's first purpose-built museums.

The architect for the circular structure was Richard Hey Sharp of York, but the design was suggested by William 'Strata' Smith, the so-called 'Father of English Geology', who realised that the wrap-round internal wall of a rotunda could provide a perfect canvas on which to display geological specimens in chronological order. Smith is said to have come up with this idea after seeing a rotunda in London, which I suspect may have been the Blackfriars Rotunda, which was built to house the Leverian Natural History Collection.

Describing the interior of the Rotunda, Nikolaus Pevsner noted how the exhibition space is reached by a spiral staircase that arrives in the middle of

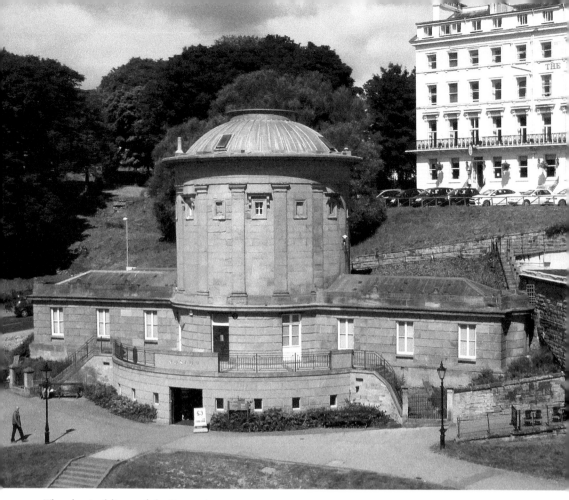

The classical lines of the Rotunda.

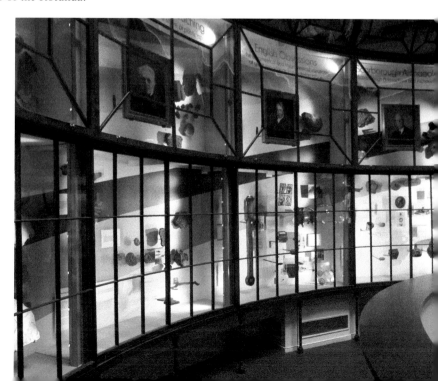

Inside the
Rotunda
Museum.

the room, while a second spiral staircase leads to a narrow gallery lined with the original showcases. William Smith's nephew, who was himself a geologist, decorated the inside of the dome with a sectional drawing of the rocks on the Yorkshire Coast.

In 1860, lower wings were added to the Rotunda, which had been constructed from stone obtained from the quarries at Hackness. This fine building material had been supplied by Sir John Johnstone, president of the Scarborough Philosophical Society, who had made Smith his land steward and had become his patron after learning about the geologist's revolutionary idea of identifying geological strata by according to the fossils they contain. Smith earned the nickname 'Strata' after using his ideas to construct the first detailed nationwide geological map.

The museum's wonderful collection comprises 5,500 fossils and 3,000 minerals obtained from Yorkshire's so-called 'Dinosaur Coast'. Its headline-grabbing exhibits include an almost-complete skeleton of a plesiosaur found at Speeton, the skeleton and coffin of a Bronze Age man discovered at Gristhorpe, and a plethora of objects from Star Carr that were fashioned from bone, flint and antler.

14. Trinity House

Richard Hey Sharp, the architect who had drawn up the plans for the Rotunda, was also responsible for designing Trinity House on St Sepulchre Street, which Pevsner described as being 'very well done'. The building has a three-bay projecting frontage and a panelled doorway surmounted by a balustrade, but the most eye-catching feature is the parapet, which carries a description of the building as 'the Hospital of Trinity House founded MDCII, rebuilt MDCCCXXXII', underneath which is a carving in relief of a ship at sea. The carving strikes me as being an illustration of the perils of life at sea, for it depicts rough waves and shows a boat with a tall crow's nest that looks as if it would present a formidable challenge to any mariner required to scale it.

This carving on Trinity House is a fitting illustration for an institution that was required, by an Act of Parliament passed in 1747, to collect from mariners a levy of sixpence per month to be used to 'support maimed or disabled seamen and the widows and children of such as shall be maimed, disabled or drowned in the Merchant Service'. Seamen were required to pay their monthly sixpence during the months when they were actually at sea. According to documents in the Maritime Heritage Centre, 60 per cent of mariners employed on Scarborough's boats spent less than five months per year at sea and only 22 per cent of them made more than one voyage per annum.

Although there had been reports of mariners in other parts of the country failing to fulfil their obligations under the 'Seamen's Sixpence Programme', the insurance scheme seems to have been well supported in Scarborough, with seamen being happy to pay their levy because the town's Seamen's Hospital was providing

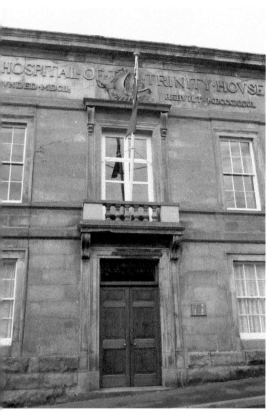
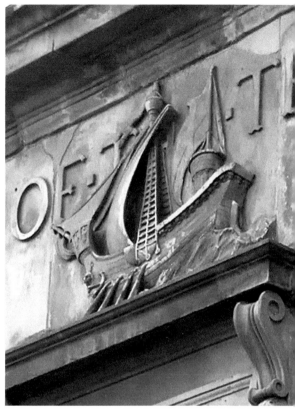

Above left: Trinity House.

Above right: A relief of a ship at sea.

such good assistance. Between 1752 and 1765, the hospital housed 236 widows and sixty elderly or disabled seamen. It is very clear that all those sixpences were being put to good use.

15. The Crescent and the Crescent Hotel

After designing the Rotunda and Trinity House, Richard Hey Sharp laid out plans for an even more ambitious development in Scarborough. Probably commissioned by John Uppleby, a wealthy solicitor and one-time town clerk, the scheme involved the construction of a long crescent-shaped terrace of town houses on land acquired from John Tindall, a member of the well-known Scarborough shipbuilding family.

Crescents had first become fashionable in Bath, where the Royal Crescent had been built between 1767 and 1774, with several other crescents being constructed subsequently in the rapidly developing Somerset spa. The 5th Duke of Devonshire,

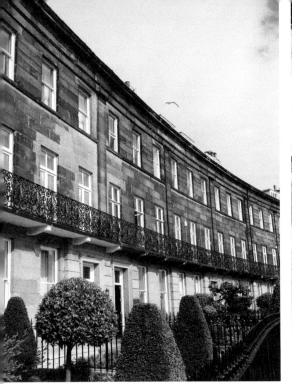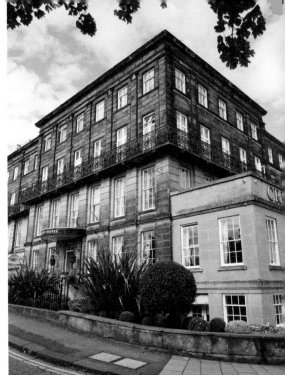

Above left: The Crescent, designed by Richard Hey Sharp and completed by Samuel Sharp.

Above right: The Crescent Hotel.

who had ambitions to make the Derbyshire spa of Buxton into the northern Bath, commissioned John Carr, the York architect known for Wentworth Woodhouse, to build a crescent, which turned out to be more elaborate in detail than Bath's Royal Crescent. Crescent-shaped terraces built in London included Park Crescent (built between 1812 and 1821 and designed by John Nash) and Grosvenor Crescent (built between 1837 and 1860), which is now the most expensive residential street in England – the average house price is a staggering £16.9 million.

The construction of a crescent in Scarborough was a clear indicator of how fashionable the Yorkshire spa had become by the early nineteenth century. The terrace took two decades to finish, not being completed until 1857. Richard Hey Sharp's younger brother, Samuel Sharp, was charged with ensuring the design remained faithful to the original concept throughout this long construction period.

A distinguishing feature of Scarborough's Crescent is the first-floor balcony, which runs the entire length of the terrace and is fronted by honeysuckle-patterned railings. Although the residences in the Crescent have rather short front gardens, they benefit from their position overlooking a park.

The Crescent terminates at the Crescent Hotel, which has twenty rooms, ranging in size from executive suites to single rooms designed for lone travellers. The hotel has a short modern extension, which is consistent in style with the original terrace, but looks rather incongruous in scale because it is much lower. Nevertheless, the Crescent is a fine survivor from Scarborough's most elegant era.

16. Scarborough Art Gallery

John Uppleby lived in a large house, dating from 1843, which looks across the park to the long crescent of town houses that was his pride and joy – in fact, Uppleby called his residence Crescent House. The Italianate-style villa has a rusticated ground floor entrance and features a balcony and a pilastered first floor. The splendid building was bought in 1942 by Scarborough Council for use as a welfare clinic and a children's nursery. It now houses Scarborough Art Gallery.

Many of the paintings in the gallery's permanent collection were donated by Tom Laughton, the hotelier, art collector and brother of Charles Laughton, the celebrated actor. As reported in the *Yorkshire Post* at the time of the Tom Laughton

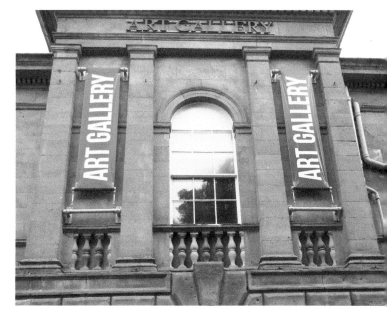

Scarborough Art Gallery, based in John Uppleby's former residence.

The rusticated ground floor of the art gallery.

Centenary Exhibition, Tom had initially donated pictures to the gallery in 1968, in order for them to hang in the Esme Laughton Room, established in memory of his wife. He later donated paintings in memory of his second wife, Isobel, and shortly before his death in 1984 he gave a further forty paintings dedicated to the memory of his third wife, Mary, bringing the total to sixty. Tom said, 'The collection is a thank-you offering to Scarborough, in recognition of the many blessings I have enjoyed here.'

The permanent collection includes paintings of Scarborough by John Atkinson Grimshaw, who had an uncanny knack of capturing scenes illuminated by moonlight or by streetlights – a fine example in the collection being *Scarborough Lights*. James McNeill Whistler, who had worked alongside Grimshaw in his Chelsea studios, said, 'I considered myself the inventor of nocturnes until I saw Grimmy's moonlit pictures.'

Other notable works include paintings by Lord Leighton, Sir Matthew Smith, Frank Brangwyn and William Etty, the first British artist who had dared to make his name as a painter of nudes. In addition, there are works by the fine marine artists Frederick and Ernest Dale and Robert Ernest Roe. The gallery also hosts temporary exhibitions of the work of the many talented local artists who live and work in a beautiful coastal area that almost demands to be represented on canvas.

17. Woodend

Tucked away on the north-western perimeter of Crescent Park, Woodend has a very grand south façade, which features a wonderful double-height conservatory that commands a spectacular view over a wooded valley. The house was built in 1835 for the civil engineer George Knowles, who spent much of his life designing bridges in Ireland. In 1870, the property was acquired by Lady Louisa Sitwell, who added the great conservatory that makes the property so distinctive. She also combined three rooms into one grand drawing room.

Lady Louisa was the mother of Sir George Sitwell, who married Lady Ida Denison. The couple had three children, Osbert, Edith and Sacheverell, who were famed for their literary pursuits, eccentricity and pretentiousness. Sir Osbert wrote poetry, novels and short stories; Sir Sacheverell penned works about art, architecture, ballet and travel; and Dame Edith wrote poetry and was a novelist. Sir George built a new library wing at Woodend and the siblings became the centre of an artistic and literary clique, which rivalled the famous Bloomsbury Set in some respects.

The Sitwell family, who had made a fortune as landowners and iron makers, had built Renishaw Hall in Derbyshire in 1625, which has remained their home ever since, whereas Woodend was sold in 1934. Now owned by a trust, the building is a centre for creative activities and provides workspaces and learning opportunities for artists.

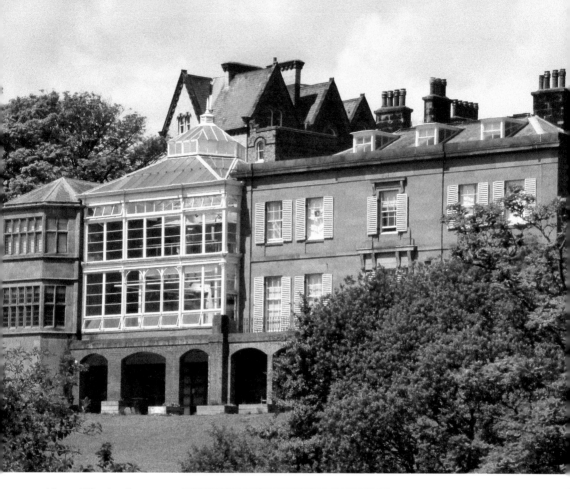

Above: Woodend, with its double-height conservatory (former home of the Sitwells).

Right: The library at Woodend.

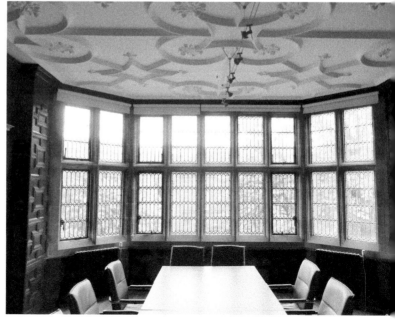

Dame Edith Sitwell, who was born at Woodend in 1887, never forgave her mother for making her wear an iron back brace and nose truss as a child with the aim of improving her posture and her features. Her parents were always strangers to her, and she never married, but she became passionately attached to the Russian painter Pavel Tchelitchew. She famously said, 'I am patient with stupidity but not with those who are proud of it.' Her *Face to Face* interview with John Freeman filmed in 1959 by the BBC is available on YouTube. It makes for viewing that is both fascinating and disturbing.

18. Scalby Mills

Scalby stands at the far end of North Bay, where the Sea Cut, a man-made flood-prevention channel, drains waters from the River Derwent into the North Sea. The area was the location for a number of mills, including a corn mill at Newby Bridge, which operated from the mid-eighteenth century until the 1950s. Standing alongside the Sea Cut is the Old Scalby Mills pub, established in 1854 after being converted from a watermill that was constructed in 1609.

Some significant Scarborough characters are associated with Scalby. It was the home of violinist Max Jaffa, leader of the Palm Court Orchestra and a member, alongside pianist Jack Byfield and cellist Reginald Kilby, of a famous trio. Max played seventeen-week summer seasons at the Spa for twenty-seven years. Tom Laughton, the donor of many paintings to Scarborough Art Gallery, retired here, and Albert Corrigan built an amusement park in an area of land he had levelled by removing a hill known as Monkey Island. The park operated for thirty years until the 1990s, when it was replaced by the Sea Life Centre. Monkey Island had been a rather incongruous landscape feature, but no more so than the new pyramid-shaped pavilions of the Sea Life Centre.

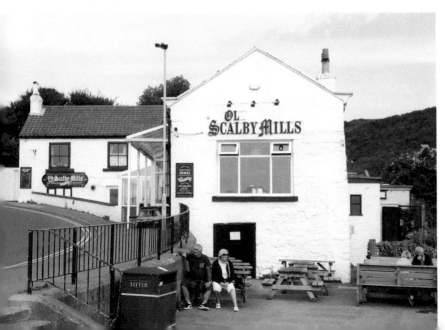

Old Scalby Mills.

19. The Crown Spa Hotel

The Crown Spa Hotel was opened in 1846 by twenty-four-year-old John Fairgray Sharpin as Scarborough's first purpose-built hotel. Designed in a Regency style by John Gibson, the building features a large portico supported by six giant columns. Knowing that holidaymakers could be wooed by the spectacular location, Sharpin placed seductive advertisements in various newspapers, describing the hotel's situation as 'exceedingly beautiful, embracing, from the rooms, balcony and adjoining pleasure grounds, an extensive view of the ocean and the romantic scenery of the Eastern Coast'.

Although the South Cliff area of the town was rather underdeveloped in 1846, the success of Sharpin's enterprise soon prompted further building along the Esplanade on which the hotel stands, causing one writer to remark that it was becoming a 'semi-aristocratic preserve'. The hotel had stabling for sixty horses and housing for carriages. However, its opening coincided with the coming of the

The Crown Spa Hotel.

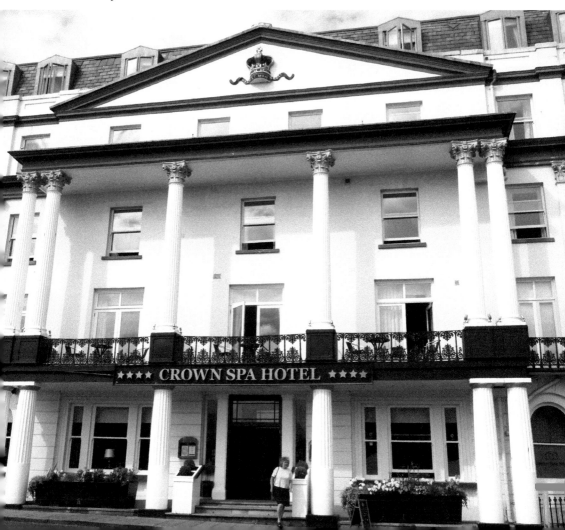

railway to Scarborough and, within a few years, many people who came to stay at the Crown were arriving by train. When he sold the hotel in 1857, Sharpin had moved on to new ventures: he had built the Assembly Room in the town centre and he was about to become Scarborough's youngest mayor.

20. Scarborough Railway Station

By 1845, Scarborough was already well established as a popular spa and a premier holiday resort, but the opening of the town's railway station in July of that year marked the beginning of a vast increase in the number of visitors, particularly working-class visitors. In fact, it was the coming of the railways that was responsible for bringing about the age of mass tourism. More than 10,000 people turned out to witness the arrival of the first train, consisting of thirty-five carriages pulled by two locomotives. A new era in the town's history was beginning.

In 1883, two new platforms were built at the station to cope with the increase in excursion traffic and two further platforms were added in 1903. A tall clock tower had been added to the station in 1882, with its baroque styling closely resembling the appearance of the clock towers that were being constructed on some northern town halls – lofty structures clearly designed to emphasize the importance of the

Below left: The Clock Tower (1882) at Scarborough railway station.

Below right: The longest railway station seat in the world.

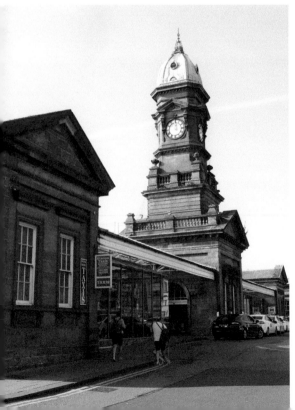

rapidly expanding cities as centres of manufacture, trade and culture. Similarly, Scarborough's station clock tower was a symbol of civic pride, rather than a way of helping passengers to catch their trains on time. Its pretentious styling is at odds with the restrained classical appearance of the three pavilions that make up the frontage of the station.

For many people travelling to the Yorkshire Coast for a week's escape from the daily grind, their first sighting of that clock tower must have been as welcoming as the first glimpse of Blackpool Tower was for those seeking similar respite on the Lancashire Coast. The popularity of taking excursion trains to Yorkshire's 'Queen of Watering Places' is illustrated by the length of the seat on Platform 1. With a length of 139 metres, it is the longest station seat in the world.

Normally the scene of joyous comings and goings, the station witnessed a tragedy in 1943, when a late-running express train arriving from Hull was wrongly rerouted by a signalman and hit another train that was waiting to depart. Four soldiers in the stationary train lost their lives.

21. The Grave of Anne Brontë

In her biography of Charlotte Brontë, Claire Harman gives a moving account of the final days of the novelist and poet Anne Brontë, the youngest member of the Brontë literary sisters. Knowing that she was perilously close to death from tuberculosis, Anne travelled with her sister Charlotte and Charlotte's friend Ellen Nussey to Scarborough, in the hope that the sea air might offer her some relief and revive memories of happy holidays she had spent at the resort with the Robinson family when she was working as a tutor to their children.

On Saturday 26 May 1849, she went for a drive on the sands at Scarborough in a donkey carriage. Distressed by the way the donkey was being driven, Anne took over the reins and told the boy who was driving the carriage that he should treat the animal better in the future. On Sunday evening, she was wheeled to the window of the room where the three women were staying so that she could watch the sunset lighting up the castle and the ships at sea. On Monday morning, Ellen carried Anne down the steps of the lodgings because she had become too weak to walk. Noticing Charlotte's distress about her condition, Anne told her sister, 'Take courage, Charlotte, take courage.' Shortly afterwards, she died peacefully, after telling her two helpers that she was 'happy'.

Anne was buried in the churchyard of St Mary's Church beneath a headstone that gives the age of her death as twenty-nine, rather than twenty-eight. A horizontal plaque unveiled by the Brontë Society in 2013 corrects this error and repeats the dedication on the headstone, which had become almost illegible due to weathering.

Anne wrote poetry and two novels, the second of which, *The Tenant of Wildfell Hall*, relates how a wife who was brave enough to leave her alcoholic husband

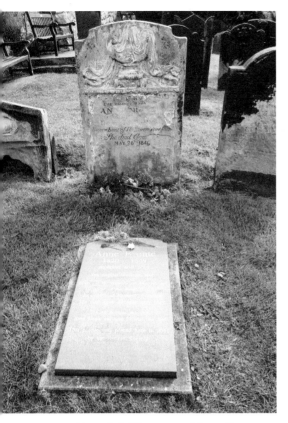
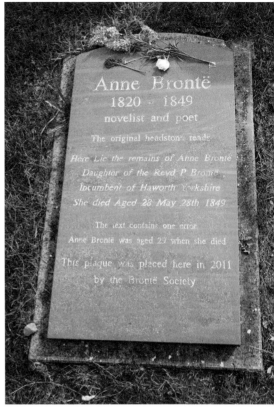

Above left: The grave of Anne Brontë.

Above right: A plaque unveiled by the Brontë Society correcting an error on the grave.

had to struggle to maintain her independence. After many years of being regarded as the least important of the Brontës, Anne is now looked upon as one of the world's first truly feminist writers.

22. Scarborough Town Hall

Two spectacular buildings dominate the skyline above Scarborough's South Bay. One is the massive Grand Hotel, described in section 31 of this book (see page 57). The other is the tall, twin-turreted wing of the Town Hall extension, designed in Jacobean style by Harry W. Smith. A mansion called St Nicholas House, designed in 1844 by Henry Wyatt for John Woodhall, had been sold to the Corporation when they were looking for a new Town Hall, after they had occupied three previous buildings over the years. Commissioned by the Corporation to extend the mansion, Smith designed a seaward-facing addition that manages to complement

Above left: The original wing of Scarborough Town Hall (John Woodhall's former residence).

Above right: The neo-Jacobean extension to the Town Hall.

and enhance the neo-Jacobean styling of the original building to which it is attached, while making a wonderful visual impact of its own.

The dining room, library and drawing room of the original house became the Cabinet Room, Members' Retiring Room and Civic Parlour of the Town Hall. In the Mayor's Parlour, there is an inkstand made from the cap of a naval shell fired during the bombardment of the town by two German battlecruisers in December 1914. As described in section 2 of this book (see page 12), this attack caused outrage and inspired a recruitment poster with the slogan 'Remember Scarborough'. The image on the poster is a reproduction of a highly patriotic painting by Edith Kemp-Welch, which hangs in the Committee Room.

Another famous painting in the Town Hall is *Scarborough Spa Promenade* by Thomas Jones Barker, which hangs in the Mayoral Corridor. It purports to show a visit made by the Prince and Princess of Wales in 1870 – a visit that didn't actually take place according to the local history society. The proximity to the prince and princess of each person depicted in the painting of this fictitious event was determined by the amount they had paid for their image being incorporated into the picture.

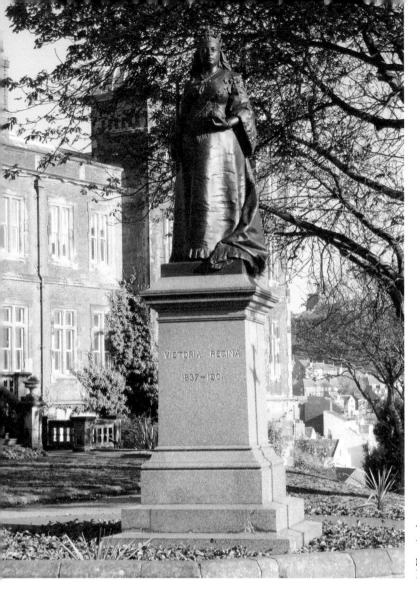

The statue of Queen Victoria in the grounds of the Town Hall.

A royal visit to Scarborough that did take place was the 1903 official opening of the Town Hall by Princess Beatrice, the youngest daughter of Queen Victoria, when the princess unveiled the statue of her mother in the grounds of the building.

23. Scarborough Public Market Hall

For many years Scarborough's street markets were held in various venues in the town: apple markets in King Street, beast markets in Queen Street, pig markets in Tanner Street, and meat markets in St Helen's Square and The Shambles. When royal assent was given in 1852 for a new market hall, the butchers' yards and slaughterhouses in the Shambles were demolished to make way for the construction of a new Tuscan-style hall faced in Whitby stone.

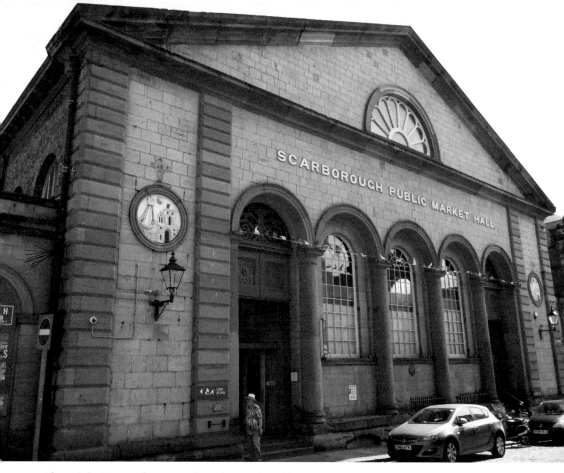

Above: The Tuscan frontage of Scarborough Public Market Hall.

Below: The main floor of Scarborough Public Market Hall.

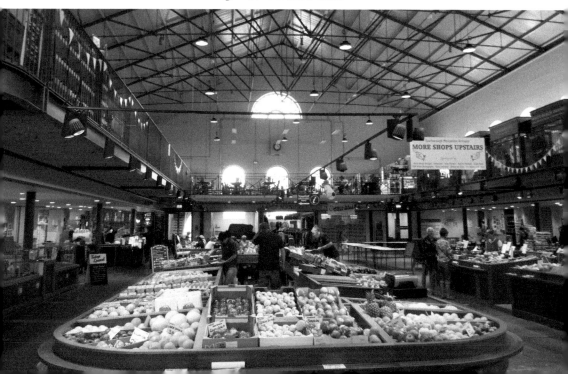

With its 46-metre length and 34-metre width, the market hall was large enough to house all the previous market stalls under one roof. When the basement, relabelled 'The Vaults', was converted to accommodate stalls in 1993, it became an 'Aladdin's cave'. Capacity was increased yet further by the addition of a new mezzanine floor during a £2.7 million restoration carried out in 2016.

The sympathetic nature of that final restoration earned Scarborough a RIBA Yorkshire Award and prompted the launch of a logo based on the flower-shaped windows that are a distinctive feature of the building. At a time when many markets are struggling, it is great to see this venue justifying its reputation as 'the Covent Garden of the North'.

24. The Swiss Chalet

Joseph Paxton was one of the great innovators of the Victorian age. When he was only twenty years of age he became head gardener at Chatsworth House, where he contributed to the planning of the repositioned estate village of Edensor and also

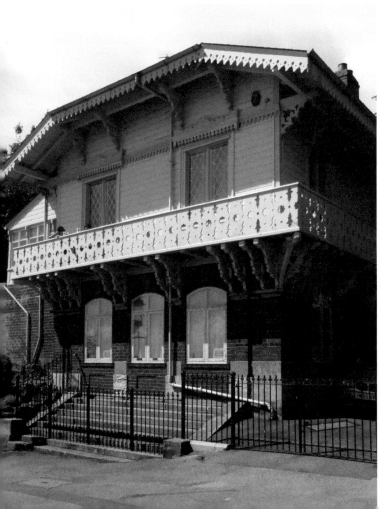

The Swiss Chalet, designed by Joseph Paxton.

designed the Emperor Fountain, new greenhouses and conservatories. His work at Chatsworth led to his employment as a designer of London's Crystal Palace. His many other commissions included the extension of the Spa at Scarborough (see page 26).

If you take the Spa Footbridge from the town to the Spa, you will be surprised to come across a large 'Swiss chalet'. This distinctive building, with its brick and timber cladding and its long crenelated balcony, was another Paxton innovation, conceived in 1858. The chalet was the residence of the spa manager until the 1950s, when it was let to Jessica Bearpark, the town clerk's secretary, who lived there until her death at the age of ninety-three in 2006. Following careful restoration, the chalet has become a holiday let that can accommodate ten people. With its fabulous sea views and its location a few feet above the sands of South Bay, this is a heritage property like no other.

25. Westborough Methodist Church

The grey ashlar frontage of Westborough Methodist Church is a massive presence in the street scene on the western approach to Scarborough. Entry to the church is made through a grand portico, the severity of which is slightly counteracted by the elaborate Corinthian capitals surmounting its tall columns and by the merest touch of playful decoration on its pediment, but the overall impression is the greyness and massiveness of a frontage that could be seen as uplifting by some or as forbidding by others. However, the brightness and spaciousness of the interior provides worshippers with a typically warm Methodist welcome.

The church had been conceived in the 1850s when Methodists had become so numerous in Scarborough that there was a waiting list to rent a pew in the Centenary Chapel in Queen Street. Responding to the need for an additional place of worship, Henry Fowler, a shipowner and ardent Methodist, offered a piece of land in Westborough, which was purchased for £500. A competition held for the design of the new church attracted three submissions and was won by William Baldwin Stewart.

Estimating that the cost of the new building would be £5,500, the Methodists appealed for subscriptions. Within the space of just one week, they had received £1,900, underlining the strength of Methodism in the town. In the event, the cost turned out to be £7,700. The foundation stone of the building was laid on 16 November 1860, and the church was opened on 4 April 1862 by Revd John Rattenbury, the president of the Wesleyan Conference.

Whitby stone was used for the 23-metre-wide front and for the sides of the church, but red brick was used for the curved rear wall. A notable feature of the interior was an elaborate pulpit with two preaching levels, which came to be known as the 'wedding cake'.

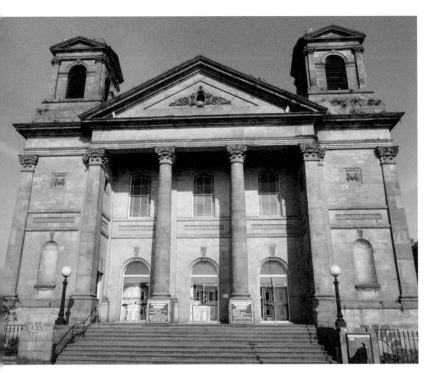

Left: Westborough
Methodist Church,
designed by
William Baldwin
Stewart.

Below: The
spacious interior
of Westborough
Methodist Church.

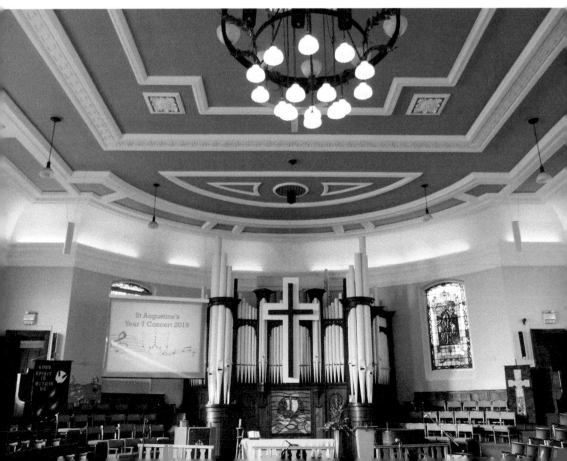

William Baldwin Stewart, the architect of the Westborough Church, went on to design the gatehouse of Scarborough's prison, where his taste for intimidating monumental styling was entirely in keeping with the function of that building.

26. St Martin-on-the-Hill

Consecrated just one year after the completion of Westborough Methodist Church, the church of St Martin-on-the-Hill was designed by George Frederick Bodley. With its saddleback roof and north tower, the exterior of the church has neither the symmetry nor the monumental presence of the Methodist place of worship, but the visual impact of its interior is positively jaw-dropping, for it is embellished by one of the finest and most dazzling collections of Pre-Raphaelite art to be found anywhere.

The church was commissioned by Miss Mary Craven, a spinster from Hull, and her architect was of sufficient standing to enable him to ask the firm of Morris, Marshall, Faulkner & Co. to design and make the decorations and the stained glass. Newly formed at that time, this company would go on to have a huge impact on Victorian taste by popularising the revolutionary art of the Pre-Raphaelites.

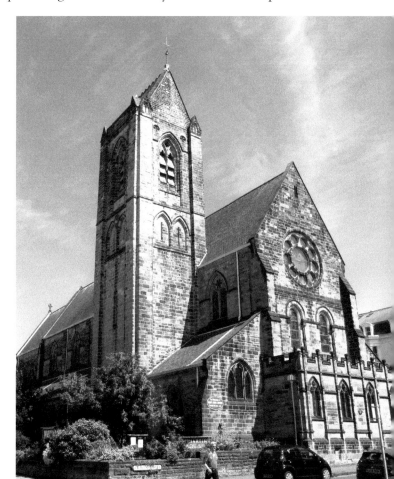

St Martin-on-the-Hill, designed by George Frederick Bodley.

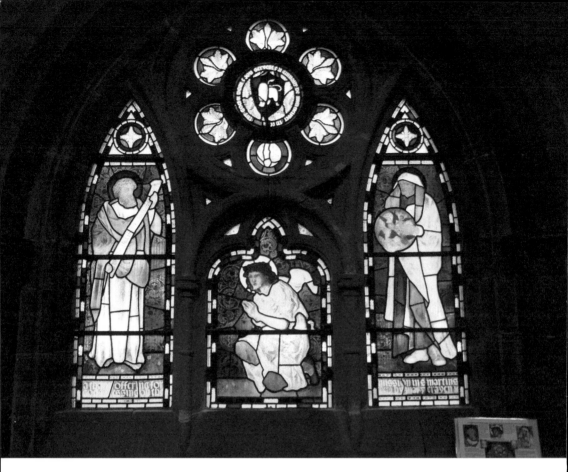

Above: The Mission Window by William Morris and Sir Edward Burne-Jones. (With kind permission of Fr David Dixon)

Left: A depiction of Adam by Ford Madox Brown. (With kind permission of Fr David Dixon)

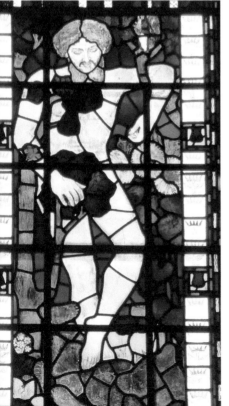

The extensive list of artists they employed for the decorative work at the church reads like a who's who of Pre-Raphaelite art.

The pulpit and the east wall are ornamented with work by William Morris, Dante Gabriel Rossetti and Sir Edward Burne-Jones; the altar wall is decorated with Burne-Jones' *Adoration of the Magi*; the ceiling decoration is by William Morris and Philip Webb; and the stained-glass windows feature designs by Morris, Burne-Jones, Rossetti and Philip Webb, as well as Ford Madox Brown, who briefly had Rossetti as one of his pupils. The organ screen was painted by John Roddam Stanhope, an artist regarded as a second-wave Pre-Raphaelite.

Apart from having a display to rival collections of Pre-Raphaelite work in art galleries in London, Manchester and Birmingham, the church has earned a reputation for the fortitude shown by its worshippers during the German Bombardment of 16 December 1914. The raid happened just as the 8 a.m. Communion service was starting. Defying and overcoming the sound of shells being fired, Revd Charles Mackarness continued with his service. The mood of defiance continued in the afternoon of that day, with the marriage of Richard Horsley and Winnifred Duphoit taking place as planned, despite the church having suffered damage.

27. The Former Scarborough Prison

As mentioned in section 25 (see page 49), the architect of the colossal gateway of Scarborough Prison, completed in 1866, was William Baldwin Stewart, who had designed Westborough Methodist Church four years earlier. His double-turreted and battlemented gateway must have increased the sense of foreboding felt by all the prisoners who were about to be incarcerated there.

The jail was designed to house thirty-six male and twelve female prisoners, plus four debtors or juveniles. Obviously pleased with their 'modern' detention facility, with its flush toilets and a lack of the overcrowding found in most prisons at that time, the Corporation held a 'roofing supper' for 300 guests at the Prince of Wales Hotel in September 1865, several months before the building was finished.

Carrying reports that are rather at odds with these claims of modernity, the Scarborough Jail website includes descriptions of a prison diet comprising 2 ounces of oatmeal and a pint of water at breakfast and supper, supplemented by a pound of bread for lunch. The site also carries descriptions of emaciated prisoners being forced to break up rocks in the exercise yard. Severe sentences included four months of hard labour for one woman found guilty of stealing a boy's jacket and a pair of trousers from her landlord.

A ferocious-looking gargoyle by the main entrance was probably meant as a warning to any prisoners with thoughts of breaking out. In any case, the prison, with 0.6-metre-thick walls encasing every cell, was meant to be escape-proof. However, one inmate did manage to escape by using an improvised rope to scale a 4.5-metre-high wall.

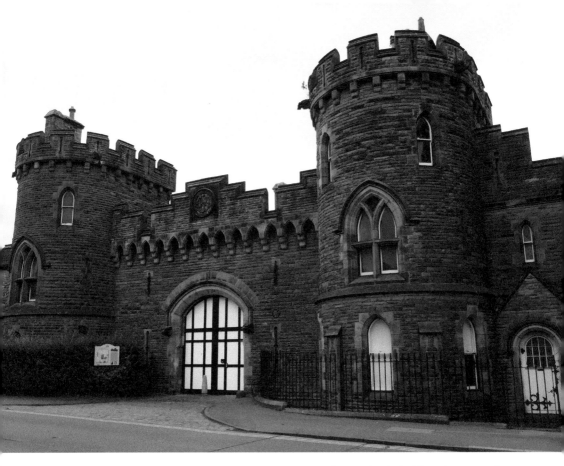

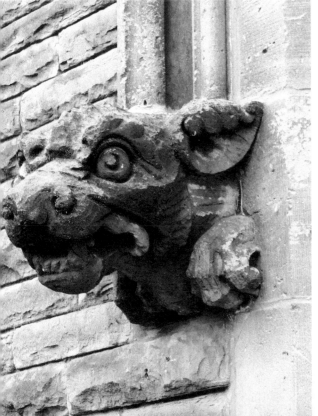

Above: The forbidding frontage of Scarborough Prison, designed by William Baldwin Stewart.

Left: A ferocious-looking gargoyle – a warning to anyone contemplating escape?

Just twelve years after it had opened, the jail was closed, with prisoners being transferred to York or Hull, because responsibility for supervising prisoners had been removed from local authorities by a new Act of Parliament. For a time, the former prison was used to house stray dogs. In 1899, the borough engineer's department took up residence.

William Baldwin Stewart's gatehouse has survived to make its intimidating presence felt on Dean Road, much as the architect's massive Methodist Church makes its formidable presence felt in Westborough.

28. Valley Road Bridge

The high-level road bridge over the deep Ramsdale Valley is one of Scarborough's most recognisable townscape features. With its three large spans and its wrought-iron girders, it is known as North Yorkshire's largest painted bridge. It also has a rather surprising history.

The bridge was designed originally to be the new Lendal Bridge in York. However, during its construction, the bridge collapsed and fell into the River Ouse. When the structure was advertised for sale after it had been dredged from

The Valley Road Bridge, originally designed as Lendal Bridge in York.

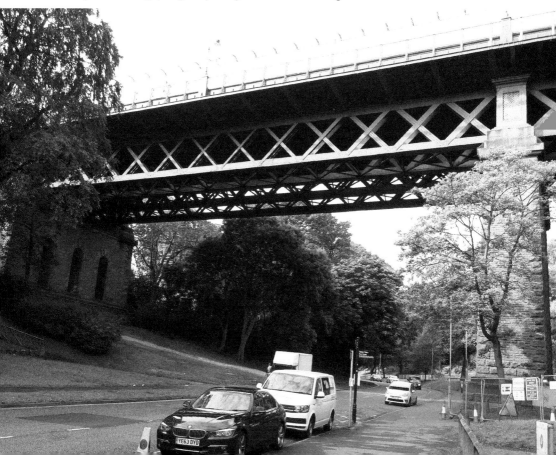

the river, Scarborough Council bought it at a basement price and used it as part of a road bridge they were planning to span the Ramsdale Valley.

In 1933, the bridge was rebuilt to accommodate the increased amount of traffic crossing over it. In 2019, it underwent a £2 million restoration, with the balustrade and the steel frame being dismantled and replaced with new components. One hundred and fifty-five years since it was first salvaged from the mud of the River Ouse, the Valley Road Bridge carries the A165 over the Ramsdale Valley and is expected to remain fit for this purpose without the need for further major refurbishment for at least three decades.

29. The Royal Hotel

The Royal Hotel stands in St Nicholas Street on the site of the Long Room, a high-class venue for balls, meetings and entertainment that was opened in 1725. The building later provided some accommodation for visitors and was renamed the Royal in 1839. In 1862, the Long Room was extended and in 1867 the Royal Hotel assumed its present form.

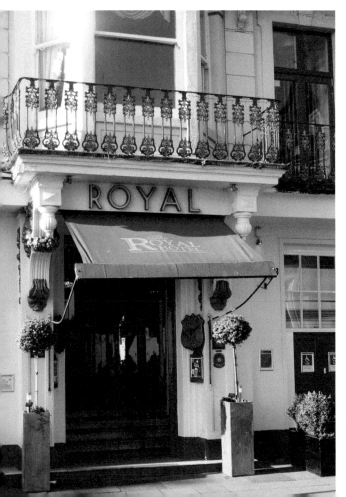

The entrance to the Royal Hotel.

From 1935 until the 1960s the hotel was owned by Tom Laughton, brother of the film actor Charles Laughton. As explained in section 16 (see page 35), Tom was a great collector of art and many of his paintings hung in the public rooms of the hotel until they were transferred to Scarborough Art Gallery. One of the suites is named after Dame Edith Sitwell (see page 38) and another suite is named after Winston Churchill, who stayed at the hotel.

Occupying a prominent position overlooking South Bay, the Regency-style hotel hosts weddings and conferences for up to 350 delegates. Facilities include an indoor heated swimming pool, a sauna and a jacuzzi – facilities that are more popular these days than the billiard and card rooms that visitors to the hotel valued in the nineteenth century.

30. Scarborough Cricket Ground

Scarborough Cricket Ground, on North Marine Road, first hosted cricket matches in 1863 after replacing the ground at Castle Hill, which had been used since 1849. The fine brick pavilion was constructed in 1895, but spectator facilities were increased over the years by the addition of a new seating enclosure in 1902, the erection of a concrete stand in 1926 and the construction of a new West Stand in 1956. The two 'ends' of this famous seaside ground are known as the Pavilion End and the Trafalgar Square End.

The first County Championship match to be played in Scarborough took place 1896, and the North Marine Ground is now the only venue apart from Headingley to be used for Yorkshire's County matches. A County match between Yorkshire and Derbyshire in 1947 attracted the ground's largest attendance of 22,946. One-day internationals were staged at Scarborough in 1976, when Viv Richards scored 119 not out for the West Indies against England, and in 1978, when Graham Gooch scored 94 for England against New Zealand.

The ground is well known as the venue for the Scarborough Cricket Festival, an end-of-season event that is one of the town's best-loved occasions. The club's website boasts: 'Over the years almost every famous cricketer that ever lived has played at the Scarborough Festival, either as an invited member of an MCC side, a Gentlemen's XI, a Players' side or as part of a visiting national touring side.'

W. G. Grace scored 174 out of a team total of 263 when playing for a Gentlemen's XI in 1885 and he was one of only three players who have ever managed to hit a ball over the houses on nearby Trafalgar Square. The legendary Don Bradman played in three Festivals, including the one held in 1930, during his first tour of England.

A full crowd watching a match at the Festival is one of England's great traditional sights, further enhanced by the fact that it is customary for the spectators to spill onto the outfield during the lunch and tea intervals to play games with family and friends.

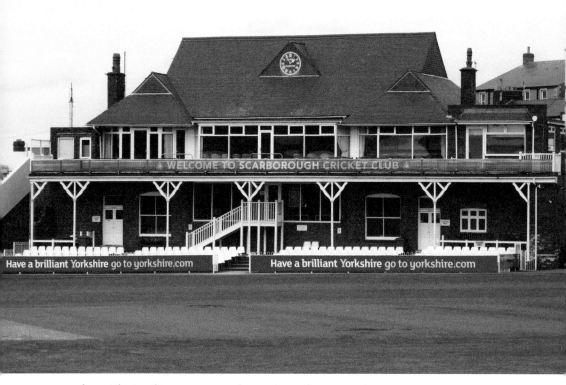

Above: The Pavilion (1895), Scarborough Cricket Ground.

Below: Seating at Scarborough Cricket Ground.

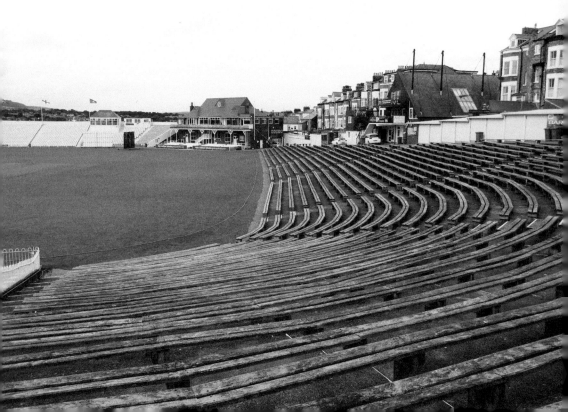

31. The Grand Hotel

Perfectly described by Richard Morrison in *The Times* as 'towering over South Bay like a massive brick ocean liner', the Grand Hotel is Scarborough's most iconic building. When it was completed in 1867, it was the largest brick structure in Europe and one of the largest hotels in the world: a forerunner of great French seaside hotels like the Negresco in Nice, the Carlton in Cannes and the Hotel du Palais in Biarritz.

The architect chosen by Scarborough's businessmen for this great expression of confidence in the town's future as a top-class holiday resort was Cuthbert Brodrick. The Hull-born architect had already designed Leeds Town Hall, one of the most impressive of the new civic buildings that were being built in many northern towns and cities as symbols of pride and confidence. Brodrick had taken the 'Grand Tour' of Europe and had made a particular study of the Second Empire style of architecture in France, some elements of which were incorporated into his design for the Grand. However, most of the elements in Brodrick's quirky plans for the building were based on other considerations. Its overall V-shape was

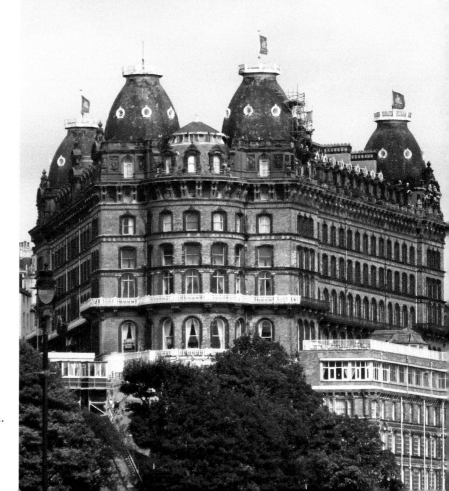

The V-shaped Grand Hotel designed by Cuthbert Brodrick in homage to Queen Victoria.

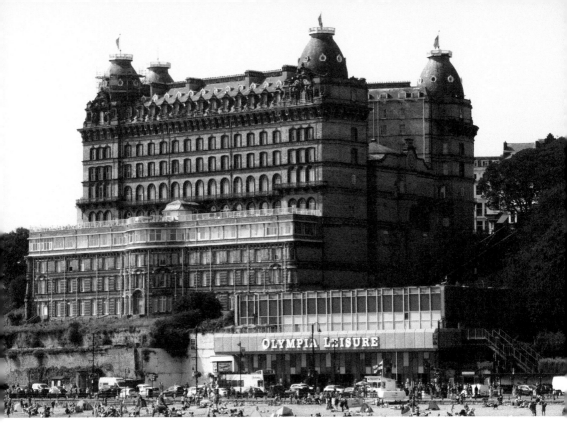

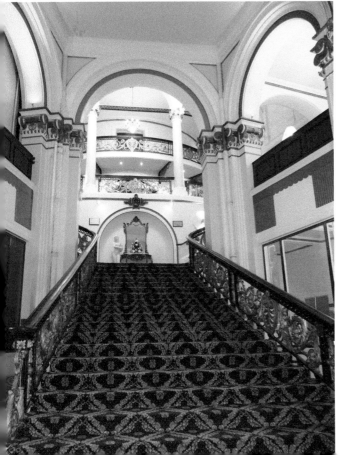

Above: 'Towering over South Bay like a massive brick ocean liner'.

Left: The main stairway of the Grand Hotel.

intended as a tribute to Queen Victoria and all its other components were based on the theme of time: four towers to represent the four seasons; twelve floors to represent the months of the year; fifty-two chimneys to represent the weeks of the year and 365 bedrooms to represent the number of days in the year. Another idiosyncratic feature was the installation of special taps that allowed guests to bathe in seawater.

Famous guests over the years have included the Prince of Wales (who would later become Edward VIII), Ramsay MacDonald and Winston Churchill. The building was hit by thirty artillery shells fired from German battlecruisers during the raid on Scarborough on 14 December 1914, but anti-aircraft guns were installed in the turrets during the Second World War when RAF personnel were stationed in the hotel. In 2017, the Grand was named by Historic Britain as one of the top ten sites that tell 'the remarkable story of Britain and its impact on the world'.

32. The South Cliff Lift

Designed as a much-needed easy means of scaling the steep incline between Scarborough Spa and the South Cliff Esplanade, located directly above it, the South Cliff Funicular Railway, which opened in 1873, was the very first funicular railway to be constructed in the UK. The railway climbs an 85-metre-long track that follows a 1 in 1.75 gradient. Passengers are transported along the steep incline in two cars (one up; one down), running on tracks that are 1.5 metres wide, each of them carrying fourteen passengers. Originally, each car was attached to a steel-cable rope. The upper car's water tank was filled with seawater pumped by gas engines through a hydraulic system until the counterbalance point was reached. The two cars then ran on their own tracks at a speed controlled by a brakeman until the descending upper car arrived at the bottom of the incline, at which point the seawater was released, allowing the procedure to start all over again.

Although the lift looks much as it did at the time of its construction, several changes have been made to its mechanism over the years. In 1879, the gas engines were replaced by steam pumps. In 1947, the water system was replaced by an electric engine and, in 1997, the lift became fully automatic. The original cars were replaced by new ones in 1935.

This lift was the forerunner of several other cliff lifts in Scarborough. Two central lifts are described in the next section. In 1930, North Bay was given its own electric-powered lift, which operated until 1996, since when it has been placed in storage in the Cornish town of Launceston. The Queen's Parade Lift, linking Queen's Parade with the Promenade Pier, was a very ill-fated affair. On the day of its opening in 1878, one of the cabins broke loose and several accidents occurred in the ensuing years until a landslip in 1887 mercifully brought an end to its operation for good!

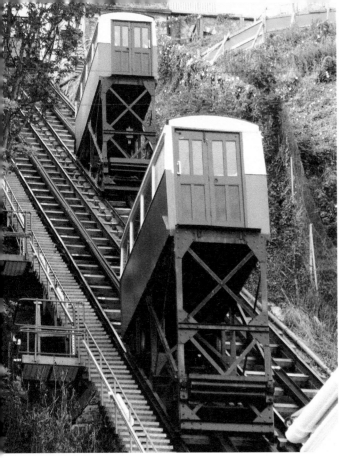

Left: The South Cliff lift.

Below: The buildings and beach at the foot of the South Cliff lift.

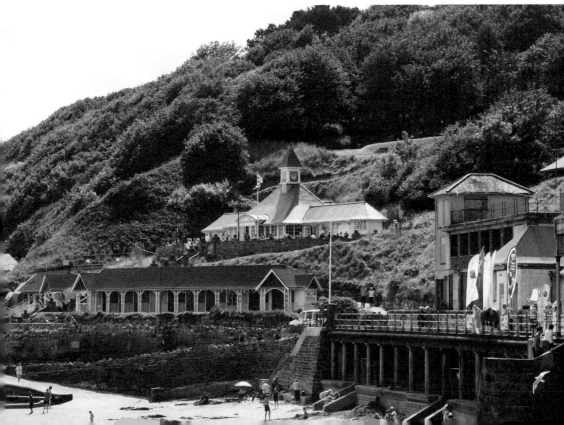

33. The Saint Nicholas Cliff Lift and the Central Tramway

In 1881, the Saint Nicholas Cliff area of the town was linked to the South Shore by a funicular called the Central Tramway. Somewhat bizarrely, the steam-operated funicular was driven from a steam house located away from the top station, leaving the drivers without a view of the cars and forcing them to guess the position of the cars by looking at marks on the rope. In 1910, the funicular acquired an electric drive, but it was not until 1932, when the two cars were replaced by new ones, that the motor was repositioned under the top station, allowing the drivers, operating from a driving station, to have a full view of the positions of the cars.

In 1929, the Central Tramway was joined by a second funicular called the Saint Nicholas Cliff Lift operating from the other side of the Grand Hotel. In the lift's early days, passengers getting onto the cars from the foot of the lift stepped into them directly from the pavement, because there was no bottom station.

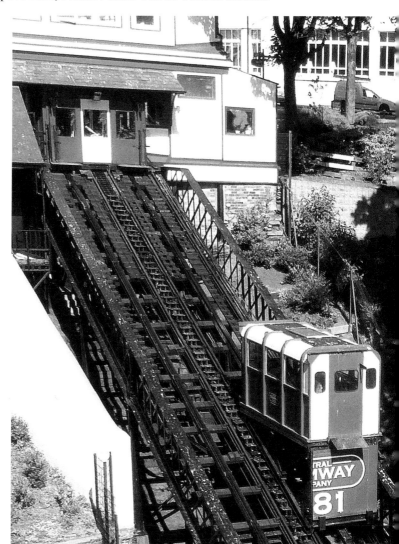

The Central Tramway.

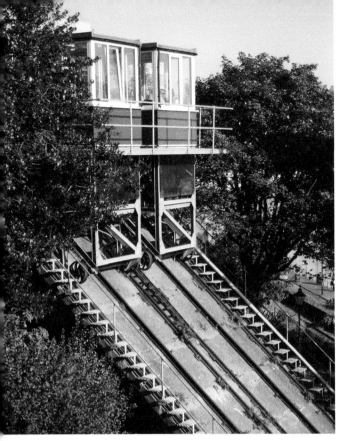

Left: The St Nicholas Café, comprising two cars anchored at the summit.

Below: St Nicholas Café with its jaw-dropping view across the sea.

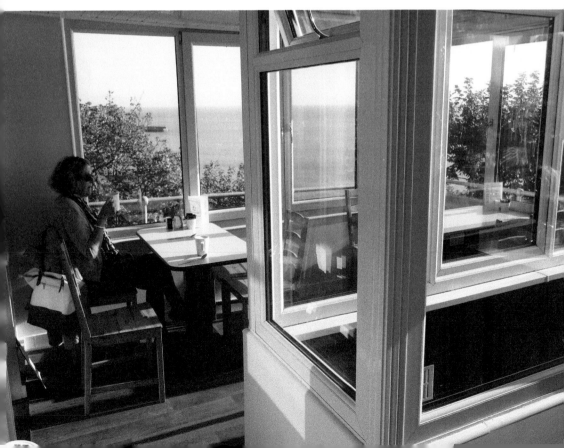

In 2007, a cash-strapped borough council decided that the lift should close because the cost of operating and maintaining it was prohibitive, not least because the council would need to spend £445,000 to meet requirements imposed by new health and safety regulations. The two cars were both moved to the top of the track and anchored permanently into position and given a surrounding balcony, as a prelude to interlinking them to create the St Nicholas Café.

The food offerings in this well-run clifftop café with a difference include breakfast, snacks and light lunches. The St Nicholas Café is a great place to eat, not only because the menu includes scones with jam and cream, paninis and pancakes, but also because it offers views over the sea and the town that are simply jaw-dropping. If you have come to Scarborough in the hope of enjoying a holiday that will give you a 'lift', this is the perfect place to start your break.

34. Castle by the Sea

The house known as Castle by the Sea, which now functions as a guest house, stands on the most spectacular site in Scarborough. It is located on the summit of a ridge that overlooks the whole of South Bay from one side and the whole of North Bay from the other side. John Atkinson Grimshaw, the great Victorian artist, was lucky enough to use the building as a holiday home from 1876 to 1879.

Grimshaw was born in Leeds in 1836. After leaving school he worked as a clerk at the Great Northern Railway, but left this secure employment to become a full-time artist. His early works were pictures of birds, fruit and blossoms, but he started to blossom as an artist when he began to produce highly realistic depictions of streets and harbours illuminated by moonlight or streetlights. A fine example is a portrait of Boar Lane, one of the main shopping streets in Leeds, which shows the carriageway irradiated by the gaslit windows of the shops and department stores.

Another Yorkshire town that caught the artist's imagination was Scarborough. His painting *Scarborough by Moonlight* is not only one of the most iconic images of the Yorkshire resort but also one of the most accomplished of his 'nocturne paintings'. Grimshaw's ability to depict moonlight as well as light emanating from the windows of buildings at night was more than matched by his facility at making realistic images of fire, as is demonstrated by his paintings *The Burning of the Scarborough Spa Saloon* and *Burning off – a Fishing Boat at Scarborough*.

In the short time that the artist resided at Castle by the Sea, he improved the property by adding a very distinctive double external stairway and a glass roof designed to illuminate his studio. Unfortunately, he had to leave his fabulous home in Scarborough in 1879 after experiencing some serious financial difficulties. The wrench at leaving behind a house with one of the best views in England must have been immense.

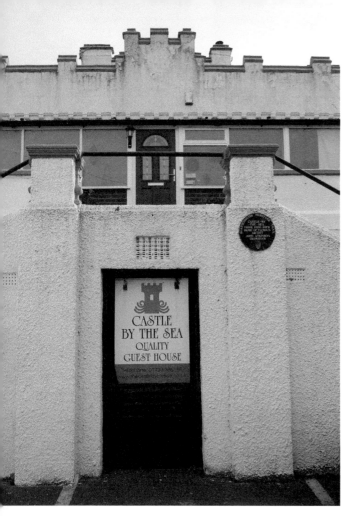

Left: Castle by the Sea, the former home of John Atkinson Grimshaw.

Below: Heritage plaque on Castle by the Sea.

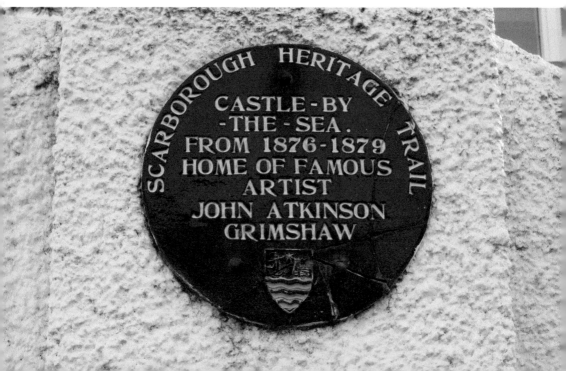

35. William Boyes' Store

In 1881, William Boyes opened a shop in Eastborough where he sold remnants and 'odd lots', including materials which could be used to make a dress or a coat at a fraction of the price of a ready-made garment. The shop was so successful that William decided to purchase a large warehouse to enable his business to cater for the high demand.

By 1886, he had acquired further units on Market Street and Queen Street and combined them to make one large store, which he called 'The Remnant Warehouse', known more popularly as 'The Rem'. This soon developed into a department store where 'virtually everything needed for home and family could be purchased at bargain prices'.

The store suffered a temporary setback in 1915 when it was destroyed by a fire that was said to be the biggest in Scarborough's history. However, a prompt

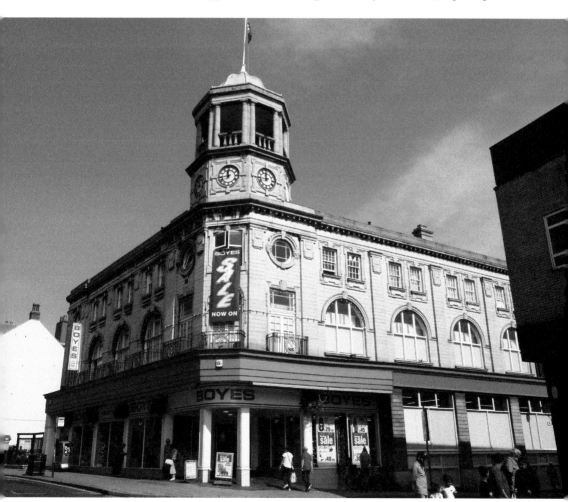

William Boyes' store, formerly known as 'The Rem'.

payout of insurance money allowed the shop to rise like a phoenix from the ashes. Today, there are more than sixty William Boyes' discount retail outlets scattered throughout Yorkshire, Lincolnshire, Nottinghamshire, Leicestershire and the North East. From its beginning as a small remnant shop, the stores in William Boyes' empire now stock 30,000 products.

36. The Lord Rosebery

The Wetherspoon company is in the habit of purchasing historic buildings and renovating them sensitively in order to convert them into popular eating and drinking venues, which are known for beginning their daily food offerings by serving early-bird customers with a hearty breakfast.

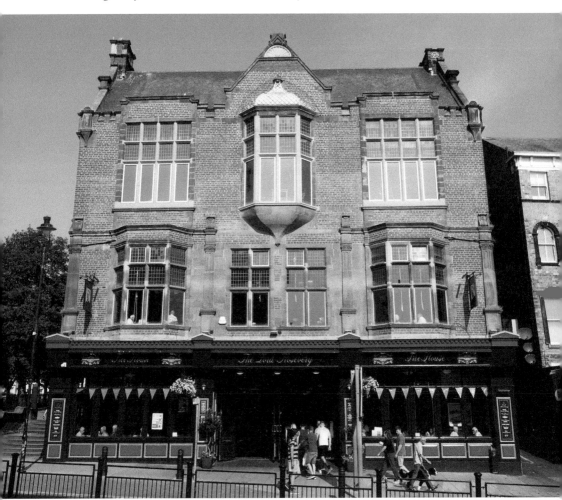

The Lord Rosebery, formerly the Liberal Club.

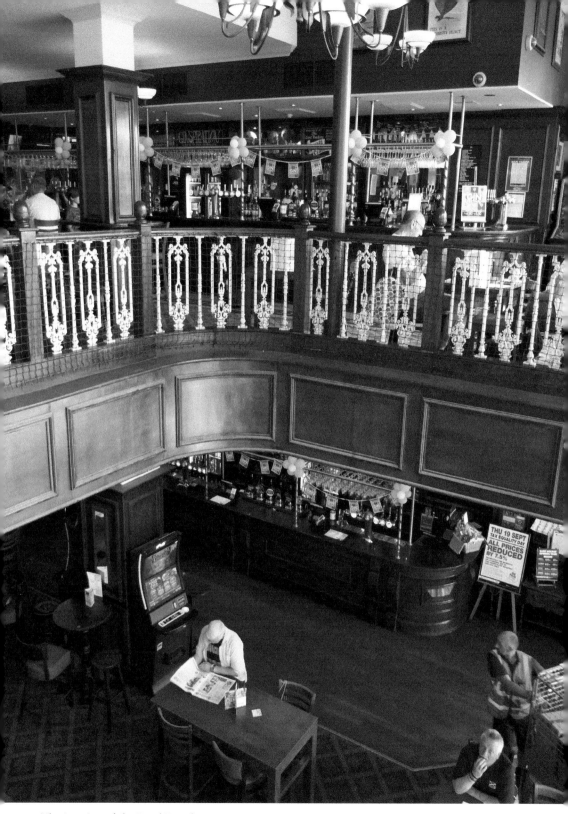

The interior of the Lord Rosebery.

The Lord Rosebery in Scarborough is a fine example of the implementation of Wetherspoon's acquisition policy. This large public house is housed in a splendid building that began life as a Liberal Club. It also served as the headquarters of the town's Liberals, who had been anxious to replace their previous headquarters in Aberdeen Walk with larger premises because party membership had grown so rapidly. The new club was opened in 1895 by Lord Rosebery (the former Archibald Primrose), who had served as Foreign Secretary under Gladstone, whom he succeeded as prime minister in 1892 to head an administration that only lasted for two rather undistinguished years. Lord Rosebery was much happier racing his horses than being prime minister. He famously said: 'There are two supreme pleasures in life. One is ideal, the other real. The ideal is when a man receives the seals of office from his Sovereign. The real pleasure comes when he hands them back.'

The opening ceremony was accompanied by a luncheon for 700 invited guests, who, according to Wetherspoon's information board, ate and drank 'liberal' quantities of food and wine. In the Second World War, the building served as a medical centre, and it was purchased two years after the conflict ended by the Scarborough Industrial Co-operative Society and renamed Unity House. In 1958, the Co-op remodelled the interior into a walk-round store.

The building has a fine Victorian gabled exterior that extends around the corner of its prominent town centre site. The very impressive interior has dark-wood panelling throughout and features an upstairs room that opens up in the centre to provide downward views from a balustraded balcony of the ground-floor bar and dining area. Customers can easily imagine that they are dining in a London club.

37. The Marine Parade and TollBooth

Scarborough's topography of two sweeping bays, divided by a massive castle-topped headland, placed considerable physical obstacles in the way of early efforts to link the two shores. Although roads had been constructed along each of the foreshores, there was a gap of 1,189 metres between the two bays at a point where the sea was left to crash onto the foot of the projecting headland.

In 1896, the council decided to construct a Marine Drive to fill the gap, not only to form a continuous road running along both shores, but also to reduce the coastal erosion that had led to several landslips below the castle. The construction of this link, repeatedly delayed by setbacks caused by damaging lashings of the wild North Sea, took ten years, ten months and ten days to complete!

When the foundation stone was laid on 30 March 1897 the work was expected to take three years, which turned out to be a gross miscalculation. This error was matched by an underestimation of the costs of the project. The final cost was twice as much as the original tender of £124,700, partially because of the considerable damage inflicted on the carriageway by the storms that occurred in January 1905, just three months after the last stone had been laid by the mayoress. One huge

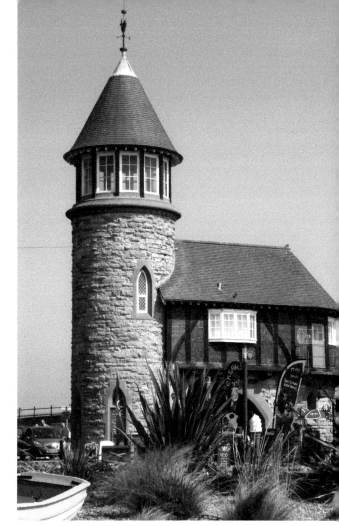

Right: The tollbooth at the entrance to the Marine Parade.

Below: The Marine Parade in the North Bay.

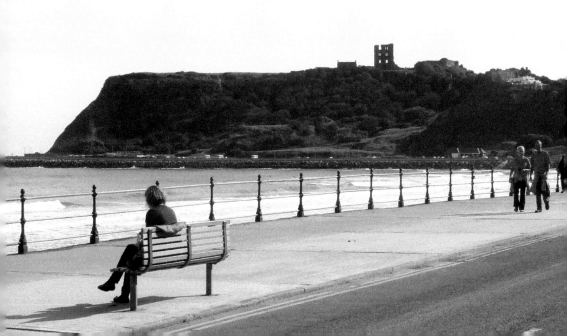

storm moved a 122-metre section of the road seaward by around 41 centimetres, leaving a large crack in the surface. An official royal opening was finally performed on 5 August 1908 by Prince Arthur, one of Queen Victoria's sons.

The Marine Drive was built as a toll road, but after the suspension of charges during the Second World War, levies for pedestrians were never reimposed. In 1950, tolls were abolished for all users and the tollhouse at the northern end of the road was removed. However, the tollhouse at the southern end of the drive was allowed to remain in place as a distinctive architectural feature. With its central archway, timber-framed upper floor and circular tower, the building has a distinctly Teutonic appearance.

38. Peasholm Park

In 1911, Scarborough Corporation purchased an area of land that had been part of the estate of Northstead, a medieval manor house. The intention of the Corporation was to use the land for the creation of a new municipal park set around a lake. This straightforward ambition took on a novel twist when the borough engineer, Harry W. Smith, came up with idea of creating gardens with an East Asian theme. Statues

Entrance to the East Asian-themed park.

Above: The lake at Peasholm Park.

Below: The Japanese bridge at Peasholm Park.

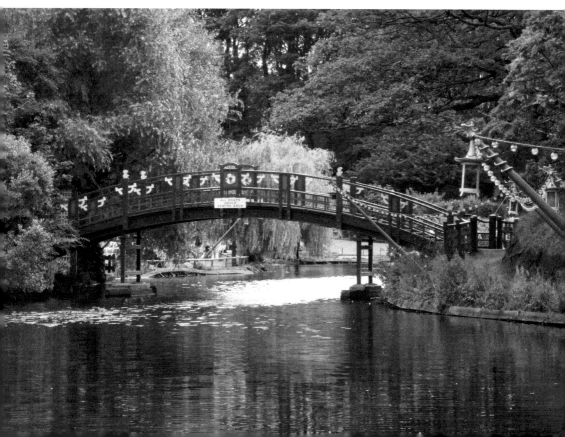

with a Japanese appearance were purchased from Killerby Hall, in the nearby village of Cayton, and exotic shrubs and flowers were imported from the home of a retired local banker who was living on the French Riviera.

Work began on the construction of a lake and an island in December 1911. This was completed by June 1912, when the official opening took place. In 1924, the park was extended into Peasholm Glen, thanks to a donation of some land by private individuals and the purchase of a further plot from the Duchy of Lancaster.

As well as luring the public with its East Asian attractions, the park became enormously popular because it was a venue for aquatic displays, musical performances, band concerts, lantern shows and firework displays, but especially because it staged mock naval battles, which have been held regularly on the lake since 1927. Council employees were used to power a fleet known as the 'smallest manned navy in the world', comprising model First World War battleships and a model U-boat. In 1929, electricity replaced manpower as a means of propelling most of the smaller boats. After the Second World War, new vessels were purchased and the mock battle became a re-enactment of the Battle of the River Plate. Mock naval battles still attract hundreds of visitors to the seating areas banked up in tiers at the side of the lake.

Peasholm Glen contains some unusual and rare trees. Lottery funds have been used to conserve the trees and to produce a leaflet that identifies those growing in the glen, including the Dickenson Elm, a fine example of a species that had been thought to be extinct.

39. The Pagoda in Peasholm Park

Harry W. Smith had produced his design for Peasholm Park as an East Asian-themed leisure and pleasure area after becoming fascinated by the Willow Pattern story. The credentials of the park were given a further boost in 1929 when the architect George W. Alderson was commissioned to design a pagoda that would stand at the head of a cascading waterfall. Having based his plans for the tower on various structures in China and Japan, Alderson was able to come up with a genuine-looking pagoda that took on a particularly magical quality when it was illuminated at night. Two years later, a set of genuine East Asian statues and ornaments were purchased to add to the authentic look of the park.

In 1999, the pagoda was burnt down by vandals. It remained closed for some time because no funds were made available to replace it, despite fierce lobbying by the many people who had obtained great pleasure from its lofty presence at the head of the teaming cascade. Eventually, a £309,500 grant was obtained from the English Heritage Lottery Fund, which enabled the pagoda to be restored to its original form – with the use, on this occasion, of fire-resistant wood. The grant also made possible the restoration of the half-moon bridge connecting the island to the mainland and funded the upgrading of the cascade that is such

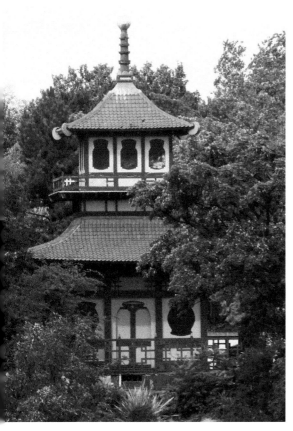 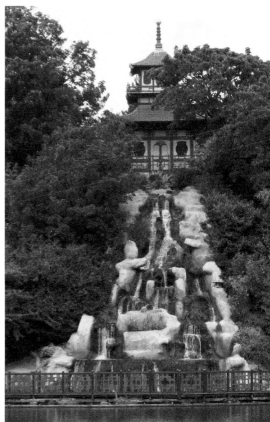

Above left: The pagoda in Peasholm Park.

Above right: The cascade and pagoda.

an important component of the impressive set piece that had been designed by George W. Alderson.

Members of a voluntary group called the Peasholm Park Friends have worked hard to regenerate the gardens and to renovate a Japanese-style pavilion that stands on the south-western side of the island. Thanks to their tender loving care, the park has been restored to its rightful place as one of Scarborough's favourite attractions.

40. Queen Street Methodist Chapel

The original Methodist Church in Queen Street was opened in 1840, just one year after the Methodists had celebrated their centenary year. Christened the Centenary Wesleyan Chapel, the building was a rather bland, plain-fronted structure. In December 1914, it suffered direct hits from shells fired in the German bombardment of Scarborough, when the roof, organ and stained-glass were badly

The Byzantine-style Queen Street Methodist Chapel.

damaged. No sooner had the building been repaired and made ready for an official reopening in 1915, than it was reduced to ashes when a large fire at the William Boyes' store (see page 65) spread to neighbouring buildings.

A brand-new chapel, designed by George Withers in Byzantine style featuring two rather squat cupolas opened in 1923. The interior, with its curved, all-round balcony, barrel-vaulted ceiling and proscenium arch, looks more like a theatre than a church, indicating that it was probably designed with the intention of making the building available for concerts, many of which are still held there.

The chapel is a somewhat exotic presence in Queen Street. Its courtyard, entered between twin stone pillars, which are probably a survival from the original chapel of 1840, leads to a wide, white-painted porch that forms a rather incongruous addition to the red-brick Byzantine building.

41. The Marks & Spencer Store

The famous British institution that is Marks & Spencer originated in Leeds as a 'Penny Bazaar', which was a market stall that had been opened in 1884 by Polish refugee Michael Marks. In 1894, Marks went into partnership with Thomas

Spencer, a former cashier with a wholesale company, and the pair opened their first shop in one of the city's famous covered arcades. By 1975, M&S had opened their first store in France and by 1999 they had launched their own version of online shopping.

Of course, it is the rise of online shopping that has contributed, in part, to the financial problems M&S have faced in recent years. There was great alarm in Scarborough when the company announced that it would be closing many of its stores. Nick Taylor, Scarborough Council's Investment Manager, believed that the closure of the town's M&S branch would be a very big loss because he regards the store as a fundamental part of Scarborough's town centre. Thankfully, the shop has escaped the axe, at least for the foreseeable future.

The Marks & Spencer store in Newborough opened in 1925. It was designed by Norman Sanderson in a style that is a slightly exotic version of the type of architecture favoured at that time by the company. The building is in two halves, with the right-hand section featuring four half-columns topped by ionic capitals. These two sections are now linked by a modern façade that runs across the front of the entire ground floor.

The site on which the store stands was occupied in the nineteenth century by the medical practice of Dr William Harland, who built and patented a steam-powered road car. His son, Edward James Harland, who was born here in 1831, was even more enterprising. He became an apprentice at Robert Stephenson's engineering works in Newcastle-upon-Tyne, before moving to Belfast to manage a shipyard,

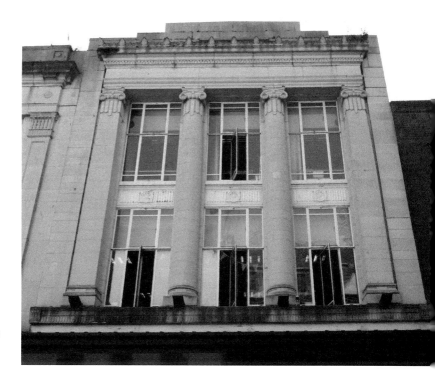

The Ionic pilasters of the Marks & Spencer store.

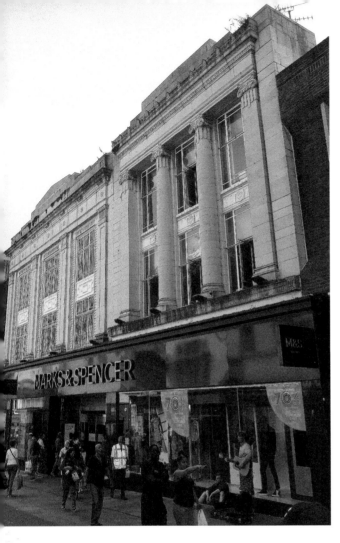

The double frontage of the
Marks & Spencer store.

which he later bought. In 1862, he went into partnership with Gustav Wilhelm
Wolff. The pair founded the Harland and Wolff shipyard where the ill-fated
Titanic would be built.

42. North Bay Railway

The 20-inch-gauge North Bay Miniature Heritage Railway opened in 1931, as
one of the first seaside miniature railways in the country. At the opening ceremony,
Alderman Whitehead, Chair of the North Side Development Committee,
addressed the mayor, Alderman J. W. Butler, saying: 'On behalf of the National
Union of Drivers, engineers and others, I have to present you, the first driver of
the North Bay Railway Engine, with your insignia of office, your oil can and your
"sweat rag".' The mayor then gamely took over the controls and drove the first
train from the terminus at Peasholm to the station at Scalby Mills. The oil can was
adorned with a blue ribbon.

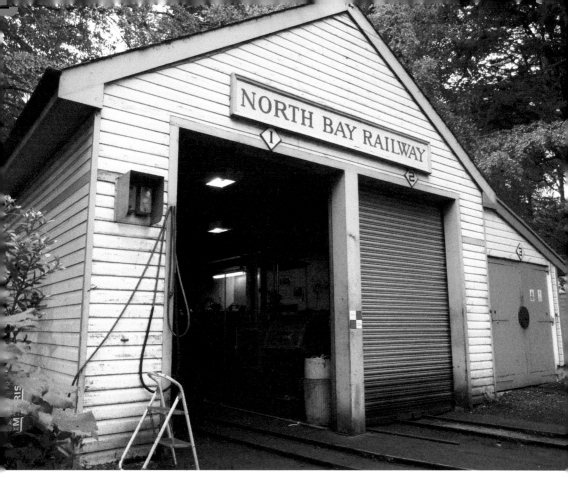

Above: The engine sheds of the North Bay Railway.

Below: An original engine of the North Bay Railway.

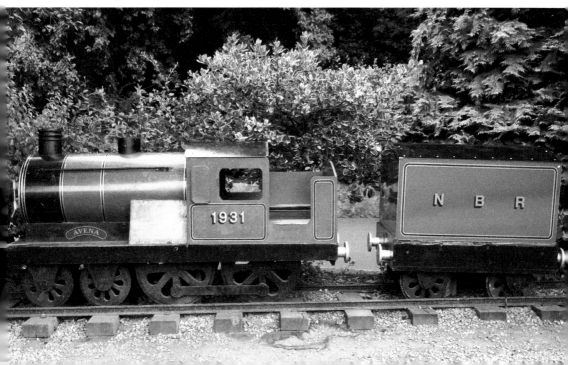

At the Peasholm end of the line, the original wood-framed loco sheds still stand alongside refreshment facilities, an information point and a public house called the Boatman's Arms, which is Yorkshire's smallest real ale pub, while at the Scalby end of the line there is a turntable. Originally, there was an intermediate station called Beach, but this has now closed. In the second season of operating, a head-on collision took place at Beach, killing the driver and injuring thirty-one passengers.

Four diesel hydraulic locomotives have operated on the line since the railway first opened. Two were built specifically for the North Bay Railway, while the other two were constructed for the former miniature railway at Golden Acre Park, near Leeds.

As well as giving visitors a fun 'heritage experience', the railway forms a scenic route between the two very popular attractions: Peasholm Park and the Sea Life Centre at Scalby. During the Second World War, the running of the railway was suspended. A tunnel in the gardens was used to store musical instruments belonging to the Royal Naval School of Music and the station signs were removed, presumably to avoid useful geographical help being given to the enemy.

43. The Open-air Theatre

In 1932, an open-air theatre was built by Scarborough Corporation on an island in the lake of Northstead Manor Gardens, with audiences being accommodated in fixed seating arranged in tiers on the bank of the lake. The attraction was opened by the Lord Mayor of London.

In the heyday of English seaside holidays, huge audiences attended the twice-weekly shows, which included theatrical performances and very lavish musical productions with casts comprising up to 200 performers. Popular musicals held there included *The King and I*, *Annie Get Your Gun* and *Hiawatha*, when Native American warriors in canoes paddled onto the stage. The cult television gameshow *It's a Knockout* was staged at the theatre over a period of eleven years, pulling in audiences of more than 10,000 for free recordings of each show.

Everything began to change when overseas package holidays began to take their toll on the number of vacations spent at the good old British seaside. Musical productions ceased in 1968 after *West Side Story* was staged at the theatre, and the dressing rooms and the stage set on the island were demolished in 1977. The last concert, given by James Last and his orchestra, was held in 1986, immediately before the closure of the venue, which was left as an embarrassing eyesore.

In 2009, Scarborough Borough Council decided to embark on a major refurbishment of the theatre, using profits from the Sands leisure and holiday complex. The lake was drained and 5,500 new folding seats were arranged in tiers. The new theatre, said to be the largest open-air theatre in Europe, was opened in 2010 by the Queen, accompanied by the Duke of Edinburgh. As a result of the filling in of the lake in front of the stage, the total capacity has been increased to

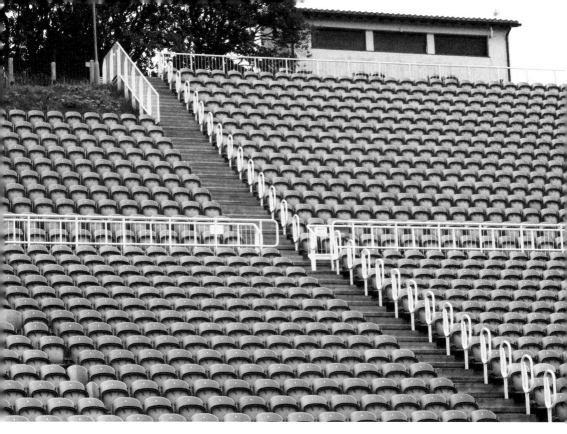

Above: The largest open-air theatre in Europe.

Right: Scarborough Open-Air Theatre.

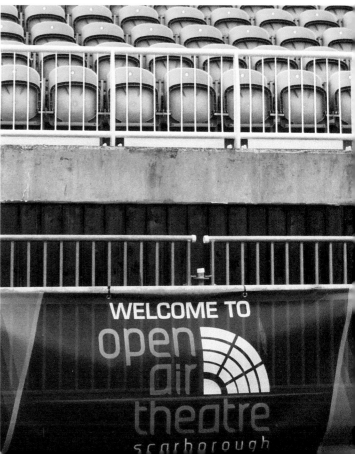

just under 8,500. Acts appearing there in the last ten years have included Elton John, Status Quo, Boyzone and Britney Spears. With 91,000 tickets for shows being sold in 2018 alone, it would seem that the glory days of open-air theatre have returned.

44. The Odeon Cinema now the Stephen Joseph Theatre

Even in a town with so many outstanding buildings, the former Odeon Cinema, now the Stephen Joseph Theatre, stands out as one of the finest. Designed by Harry Weedon in a superb version of the art deco style, the cinema opened in 1936 as one of the first of some 300 cinemas to be built in Britain for the Odeon Cinema chain. Standing on a corner plot between Westborough and Northway, the building has a curved corner entranceway that sits below a projecting canopy,

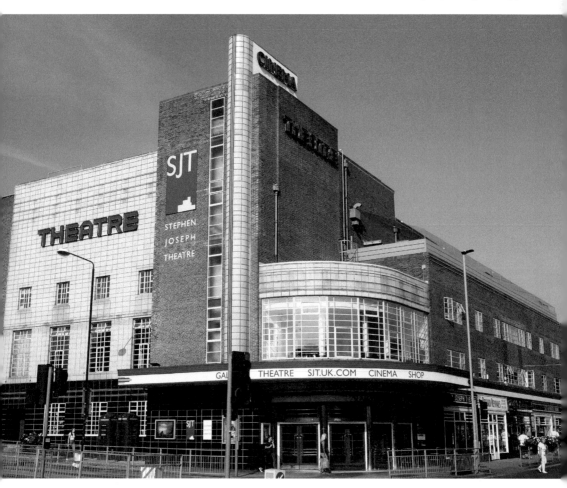

The fabulous art deco design of the former Odeon Cinema.

The theatre in the round, with a stage lift built into the floor.

above which is a curved outer wall clad in the faience tiles that also decorate much of the main block. But the most eye-catching of all the elements that make up this striking design is a tall tower, which has a full-height, metal-framed window located alongside an even taller projecting fin.

The cinema closed in 1988, but the sad demise of this great building was followed by its miraculous resurrection in 1996 as the Stephen Joseph Theatre. Stephen Joseph was a theatrical pioneer who had established Britain's first theatre-in-the-round in 1955 on the first floor of Scarborough's library, where playwright Alan Ayckbourn became the artistic director. During his time there, Ayckbourn staged world premieres of 239 new plays, including many of his own. In 1976, the theatre moved to the former Scarborough Boys' High School as a temporary measure until more suitable premises could be found.

It was the former Odeon Cinema that was chosen to fulfil Stephen Joseph's long-held dream of finding a permanent home for his theatre-in-the-round, which he described as 'an intimate, compact crucible'. All the wonderful art deco features of the Odeon were faithfully preserved and lovingly renovated, while the interior was refashioned into a 165-seat studio-cum-cinema and a 404-seat theatre-in-the-round, fitted with an innovative stage lift to facilitate set changes

and a 'trampoline' to allow technicians easy access to the lighting grids. As Nick Ahad of the *Yorkshire Post* said, 'Fish and chips by the sea followed by world-class theatre. It doesn't get much better.'

45. Luna Park Funfair

As well as being a great favourite with young visitors, the Luna Park Funfair, located at the northern end of South Bay, near the tollbooth, forms a prominent element in Scarborough's townscape, particularly when it is illuminated in the late evening.

The entrance to the Luna Park Funfair.

The funfair takes its name from the original Luna Fair, an extravaganza of rides, ornate towers and cupolas lit by 250,000 electric lights, which was erected in 1903 by Frederick Thompson and Elmer 'Skip' Dundy at Coney Island in Brooklyn. Frederick Ingersoll opened his own versions at Pittsburgh and Cleveland, and this was followed by the construction of forty-four large Luna Parks around the world. Today, the name Luna Park tends to be used for smaller attractions, like the one at Scarborough.

The Scarborough Luna Park was operated for many decades by the Tuby family of showmen who owned a number of fairground attractions throughout the north of England and hired out waltzers, roller coasters, carousels and dodgems. George Thomas Tuby, known as 'GT', had the double distinction of being mayor of Whitby in 1978 and mayor of Scarborough in 1986. He even commissioned a painting of the Queen and presented it to Scarborough Town Hall. The picture was based on a transparency supplied by Buckingham Palace.

In 1994, the Luna Park was badly damaged by a fire, but was reopened three weeks later and given new rides. The 14-metre Ferris wheel, which had dominated the Luna Park, had acted like a beacon to attract people to the fairground. However, the wheel was in need of renovation and was dismantled by the new owners, Dane and Cassie Crow, who took over the running of the park in 2019.

Dane Crow is a member of a family that has long-standing connections with the fairground trade, dating back to his grandfather William Crow Sr. The family operate children's rides in the summer at Redcar and travel throughout the UK and Ireland to provide various rides for funfairs. At the Luna Park, they plan to introduce new and updated rides and attractions. Fortunately, their plans include the retention of old favourites, not least the dodgems.

46. Brunswick Shopping Centre

Scarborough was rather late in acquiring a covered shopping centre (other than the indoor market), which is somewhat surprising given the often inclement winter weather and the fact that the nearest large shopping town is York – 40 miles away. The Brunswick Shopping Centre, also known as the Brunswick Pavilion, was built in two phases, in 1990 and 1991. The construction of the centre involved the demolition of a number of shops, as well as the Quaker Meeting House, which was designed by Fred Rowntree and constructed in 1894. Using the financial compensation they received, the Quakers erected a new meeting house on Woodland Drive, near Scarborough General Hospital.

The insertion of large new covered precincts into those towns and cities that are characterised by their Victorian and Edwardian buildings can often bring about the destruction of valued townscapes – an example being the complete transformation of Market Street in Manchester as a result of the erection of the Arndale Centre. The architect of Scarborough's Brunswick Centre did make some

Above left: The entrance to Brunswick Shopping Centre.

Above right: The interior of Brunswick Shopping Centre.

attempt to be deferential to neighbouring buildings by designing bow-display windows on the York Place frontage of the building to match the windows of the buildings on the opposite side of the road. However, the remainder of that façade is very bland and the main entrance to the indoor precinct takes the form of a rather thin gabled 'pavilion' that is a somewhat incongruous addition to the streetscape.

The centre has 12,542 square metres of retail space and comprises thirty-one shops, with many high street names being represented, including Holland & Barrett, Bon Marché, Trespass, Next, Clinton and Roman. The shops are arranged on two levels and the on-site car park has spaces for 350 cars.

The *Bathing Belle* sculpture, commissioned by the Scarborough Civic Society and designed by Craig Knowles, stood in front of the centre until it was put into storage for two years during the pedestrianisation of Westborough. Depicting a modestly attired female Victorian swimmer stepping out of a bathing machine, it has now been re-erected at Peasholm Gap at the end of North Bay.

47. The Opera House Casino

The Opera House Casino on St Thomas Street stands on a site where entertainment venues have operated under many different names over the years. The first of these was Charles Adnam's Grand Circus, established in 1876 in a wooden building, which was replaced one year later by the brick-built Hengler's Grand Cirque. This building underwent several renovations and a bewildering succession of name changes over the years: Zalvas Hippodrome Theatre, New Hippodrome Theatre, Opera House and Hippodrome Theatre, Opera House and Hippodrome, Grand Opera House and, finally, the Royal Opera House, which was demolished and replaced in 2005 by the Opera House Casino.

This latest incarnation has been described by the Shaw family as their 'dream venture'. The £7 million development of their casino was made possible by changes to the gambling laws brought about by a new Gaming Act, which saw permission being granted for eight large casinos and eight smaller ones in various locations throughout the country. The establishment of a large new casino in the town, which was the first to be opened in Britain after the change in the

The Opera House Casino.

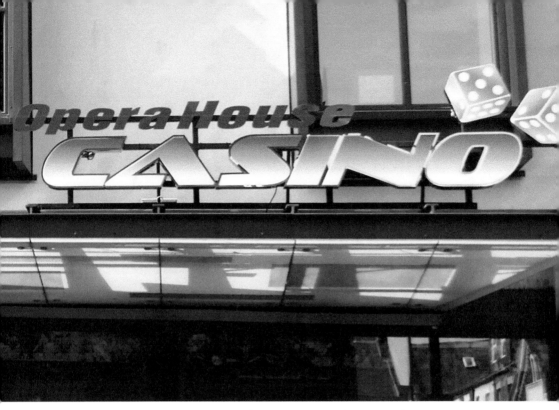

The first casino opened in Britain after the change to the gaming laws.

law, was applauded by some people as 'the biggest entertainment investment in Scarborough for over 30 years' and a much-needed boost to the local economy, but criticised by others as a temptation for people to engage in activities that could have damaging social repercussions.

The casino, which opened in October 2005 to the accompaniment of entertainment provided by a troupe of Las Vegas-style showgirls, occupies 23,000 square feet of space and contains eleven gaming tables, twenty electronic gambling terminals and twenty slot machines, as well as a restaurant and three bars. Large screens show sporting events and the building is a venue for poker tournaments. It was reported that more than 5,000 people had signed up for membership even before the doors of the casino had opened, which delighted company director Nikolas Shaw, who said: 'Our team of experts have made sure that the venue is the most luxurious casino in Britain. After three years of hard work, it's great to see membership numbers breaking records.'

48. The Captain Sydney Smith Bridge and the *Diving Belle*

In the millennium year, Scarborough Council commissioned a twin-leaf 'bascule' footbridge to link the Old Pier with the Lighthouse Pier. The white-painted bridge, constructed by the specialist engineering firm Qualter Hall, is an elegant structure designed to be raised to allow craft with tall masts to pass into the new East Harbour. The structure was opened in January 2000 by the local MP, Lawrie

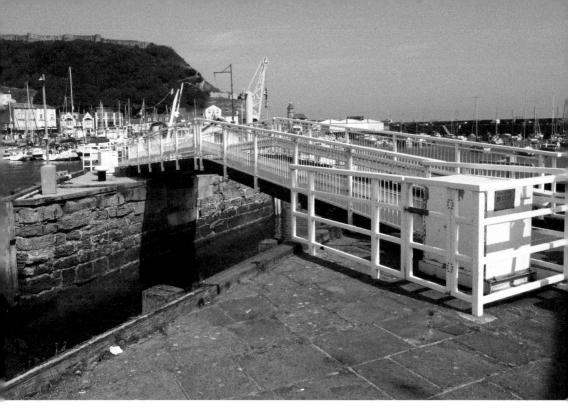

Above: The Captain Sydney Smith Bridge.

Below: The Captain Sydney Smith Bridge, the lighthouse and the *Diving Belle*.

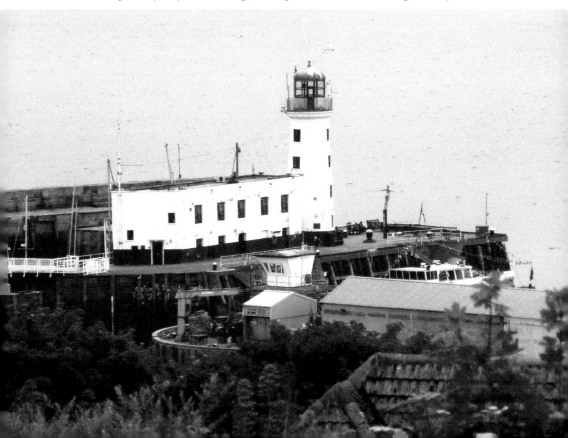

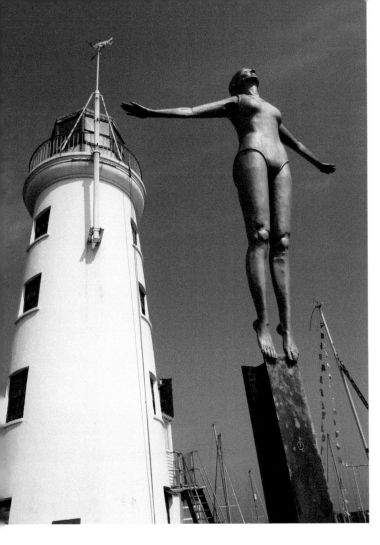

The *Diving Belle* statue and lighthouse.

Quinn, in the presence of Captain Sydney Smith MBE, the former harbour master and naval commander who had been the editor of Olsen's *Fishermen's Nautical Almanac*. When Captain Smith died later that year, it was decided to name the new structure 'The Captain Sydney Smith Bridge'.

The bridge has brought a considerable visual improvement to the approach to Scarborough's lighthouse, which was further enhanced in 2007 when the *Diving Belle* statue was unveiled. Designed by Craig Knowles, the sculpture is one of a pair of sculptures commissioned from the artist by the Scarborough Civic Society. Craig describes the figure as representing 'Scarborough in the 21st century moving confidently into the future'. Standing on tiptoes on a steel plinth next to the lighthouse with her arms outstretched, the female figure looks as if she is about to dive into the sea.

When Craig's second sculpture, the more modestly dressed *Bathing Belle*, was moved from Westborough (see page 84) to Peasholm Gap, the Civic Society's president, Adrian Perry said, 'I'm delighted that the *Bathing Belle* has been installed at Peasholm Gap. She has a beautiful view of the sea and will

be a permanent reminder of how ladies went sea-bathing at the turn of the twentieth century.'

Aside from sponsoring sculptural enhancements, the Scarborough Civic Society arranges for blue plaques to be placed on buildings of historical significance and publishes excellent guidebooks describing the town's architectural legacy. The society also keeps a watchful eye on proposals for new buildings that could damage that legacy. At the time of writing, they are rightly concerned about some of the designs being considered for a new development on the key site of the former Futurist Theatre in South Bay.

49. The Sands

Despite its dramatic geography and magnificent sea views, Scarborough's North Bay has never achieved the popularity of the resort's South Bay. The construction of the Marine Drive did help to draw more visitors to North Bay, at least to enjoy bracing walks along the long promenade, but other attempts have met with limited success until the recent development of The Sands.

The Sands seen from Castle by the Sea.

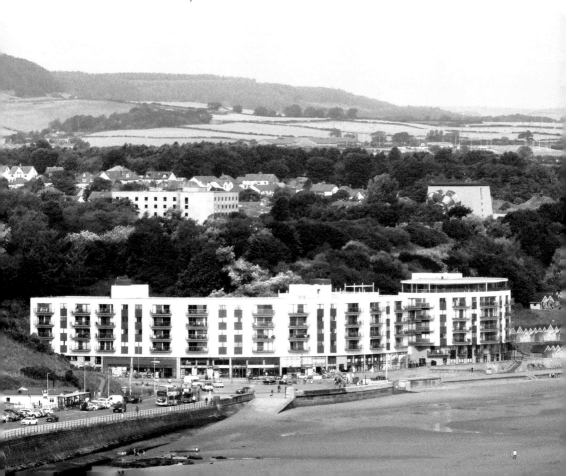

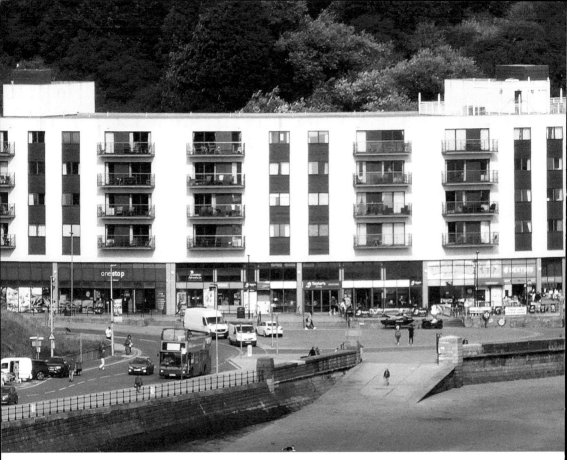

The Sands at the end of Marine Parade.

Two cliff funicular railways in the lesser-used bay had limited lives. A railway installed in 1869 had to be closed in 1887 after a series of landslips and accidents, and a North Bay Lift, erected in 1930 using two cars on twin tracks, lasted until 1996 when £75,000 would have been needed to put right corrosion and mechanical problems. A North Pier, designed in 1866 by Britain's foremost seaside architect, the wonderfully named Eugenius Birch, only lasted until 1905, when a great gale wrecked most of the structure, leaving the seaward end of the pier stranded in the sea.

There is no doubt that the completion in 2008 of The Sands, a stylish white-fronted development containing holiday apartments, has brought a great boost to the area. The renting of some of the apartments comes with free use of new beach chalets that have been erected alongside the complex. The Sands development has several other up-to-the-minute facilities: an 'electrically-enabled' car park (meaning that it has charging points for electric cars); a fitness suite; a surf shop, providing lessons and equipment for surfing, kayaking, and stand-up paddle boarding; a café bar; a restaurant; a bar; a convenience shop; and a waffle and sandwich shop. All in all, this is a superbly appointed holiday venue.

The wonderful visual appeal of Scarborough's South Bay is based on the Grand Hotel and the Spa counter-balancing the visual dominance of the castle on its

headland at the opposite end of the bay. Since 2008, the Sands development has provided a similar visual counter-balance to the dominance of the castle in North Bay. The curve of the bay no longer peters out when it reaches Peasholm Gap, but concludes in a fine seaside structure worthy of Yorkshire's premier resort.

50. Scarborough Maritime Heritage Centre

After five years in the making, Scarborough's Maritime Heritage Centre opened on 12 December 2009 in Eastborough. The community-run museum is a wonderful resource for anyone interested in the town's maritime history. It contains a huge collection of archive photographs, articles and historical artefacts, which are made readily available for everyone to view and access. Given the extent of the collection, it is useful to have volunteer guides on hand for people who may need assistance in searching for information. Volunteers also undertake research in response to requests from the public and they are able to give talks about the town's maritime history to various groups. The centre has a treasure chest of artefacts that can be loaned to schools and its excellent website includes 500 pages of articles about the history of Scarborough and the Yorkshire Coast.

Scarborough Maritime Heritage Centre.

At work in Scarborough Maritime Heritage Centre.

This fine 'Museum of the Sea' exhaustively covers the many aspects of Scarborough's maritime history, including the town's former major industries of shipbuilding and herring fishing, together with accounts of so-called 'big game tunny fishing' in the 1930s and 1940s. References to smuggling are covered, as are accounts of Scarborough's traumatic experience on the day of the bombardment by German battlecruisers in the First World War. There are exhibits relating to the vital role played by RNLI lifeboats and the Royal Naval Patrol Service, as well as reminders of the life of Edward James Harland, the co-founder of the Harland and Wolff shipyard in Belfast, where the *Titanic* was constructed. There is also information about Scarborough-born James Paul Moody, the *Titanic*'s sixth officer who died when the liner sank.

It is hardly surprising to find that this excellent museum has received a number of notable accolades. The centre's website was voted 'the best maritime family history website' by the BBC's *Who Do You Think You Are* magazine in 2011, and the teams of volunteers who run the centre won the highest possible praise when they won the Queen's Award for Voluntary Service in 2016.

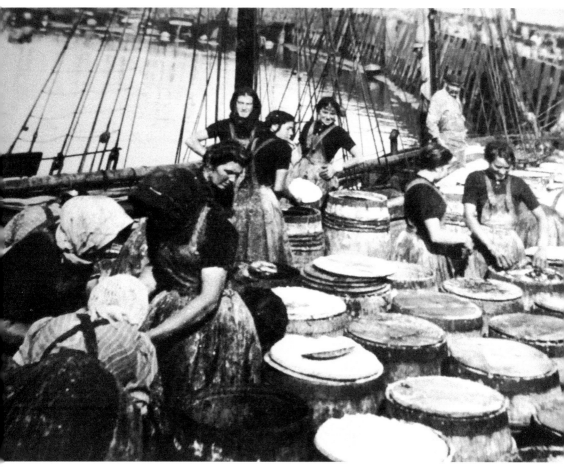

Herring girls at work. (Archive photograph courtesy of Scarborough Maritime Heritage Centre)

Bibliography

Addyman, John and Bill Fawcett (editors), *A History of the Hull and Scarborough Railway* (Kestrel Railway Books: 2013)

Ayckbourn, Alan (commentary) and Adrian Gate (photography), *Stephen Joseph Theatre: A Photographic Record* (The Stephen Joseph Theatre: 1993)

Binns, Dr Jack, *A History of Scarborough* (Blackthorn Press: 2001)

Brandon, Ed and David, *Curiosities of York* (Amberley Publishing: 2013) – Section on Lendal Bridge.

Branagan, Mark, 'Display Marks Laughton Centenary' (*Yorkshire Post*, 14 March 2003)

Clark, Jeremy, 'The King Richard III House' (*Yorkshire Journal*, No. 4, Winter: 2015)

Dale, Sharon, 'Historic Home for Sale' (*Yorkshire Post*, Saturday 3 Oct 2015)

Downes, Kerry, *The Georgian Cities of Britain* (Phaidon: 1979)

Goodhall, John, *Scarborough Castle* (English Heritage: 2013)

Hattersley, Roy, *Goodbye to Yorkshire* (Victor Gollancz: 1976)

Harman, Claire, *Charlotte Brontë, A Life* (Viking: 2015)

Hillaby, John, *John Hillaby's Yorkshire* (Constable: 1986)

Morris, Richard, *Yorkshire, A Lyrical History of England's Greatest County* (Weidenfeld & Nicolson: 2018)

Morrison, Richard, 'Scarborough's Grand Hotel' (*The Times*, 1 June 2018)

Pevsner, Nikolaus, *Buildings of England: Yorkshire, The North Riding* (Penguin: 1966)

Rhodes, W. M., *Scarborough: A History of the Town and its People* (La-Di-Dah Publishing: 2018)

Scarborough and District Civic Society, *The Scarborough Heritage Trail, Parts 1 and 2* (2017)

Scott, Selina et al. *The Yorkshire Coast* (Great Northern Books: 2011)

Sellars, Jane (editor), *Atkinson Grimshaw: Painter of Moonlight* (The Mercer Art Gallery: 2011)

Singleton, F. B. and S. Rawnsley, *A History of Yorkshire* (Phillimore: 1986)

Smith, Mike, *Bradwell's Book of Yorkshire* (Bradwell Books: 2016)

Telford, John, *The Life of John Wesley* (Hodder and Stoughton: 1886)

Wainwright, Martin, 'Yorkshire has its Day – and the World's longest Railway Platform' (*Yorkshire Post*, 1 August 2012).

A Guide to Scarborough Town Hall – a leaflet given to the borough of Scarborough by the Scarborough & District Civic Society in their 50th anniversary year.

Exhibition Leaflets in the Scarborough Maritime Museum

Scarborough Shipbuilding
Trinity Seamen's Hospital

Radio and Television Programmes

BBC, *Face to Face* (John Freeman talking to Dame Edith Sitwell), 1959
BBC, *St Martin on the Hill Bombardment Wedding*, 12 February 2014, retrieved
10 January 2015

Useful Websites

boyes.co.uk
britishlistedbuildings.co.uk
crownspahotel.com
dayoutwiththekids.co.uk
discoveryorkshirecoast.com
faithyoungwriter.co.uk (Scarborough Lighthouse)
johnatkinsongrimshaw.org
operahousecasino.co.uk
northyorkshirecoastmethodists.org.uk
revival-library.org (The Journal of Revd John Wesley)
scarboroughcricketclub.co.uk
scarboroughjail.co.uk
scarboroughmaritimeheritage.org.uk
scarborough360.co.uk (Scarborough Spa Bridge)
scarboroughmuseumstrust.com
thebeautyoftransportcom (Classical railway stations: Whitby and Scarborough)
westboroughmethodistchurch.org.uk

Acknowledgements

The illustration of the Roman signal station, as it may have appeared in the fourth century AD, appears on English Heritage's public information board. Fr David Dixon of the church of St Martin-on-the-Hill kindly gave me permission to photograph the fabulous Pre-Raphaelite stained-glass windows in his church. The archive photograph of the Scottish herring girls is reproduced with permission of the Scarborough Maritime Heritage Centre.

I am immensely grateful to my wife Jo-Ann, who gave me unfailing support and advice throughout the preparation of this book and accompanied me on numerous research and photographic visits made to Scarborough. My daughter Charlotte also gave me invaluable advice and, like Jo-Ann, she was meticulous in reading and correcting the initial draft of the book. Any errors that remain are, of course, solely my responsibility.

About the Author

Yorkshire-born Mike Smith is a graduate of Leeds University and a former headteacher of Silverdale School, Sheffield. He has written hundreds of articles about people and places for a wide variety of magazines, and he is the author of numerous topographical books and guidebooks covering various regions of England and France. Mike's enduring love affair with Scarborough began with joyous childhood holidays spent in the resort and developed into a never-ending fascination with the town's history and architecture.